Beauty of the Canadian Rockies

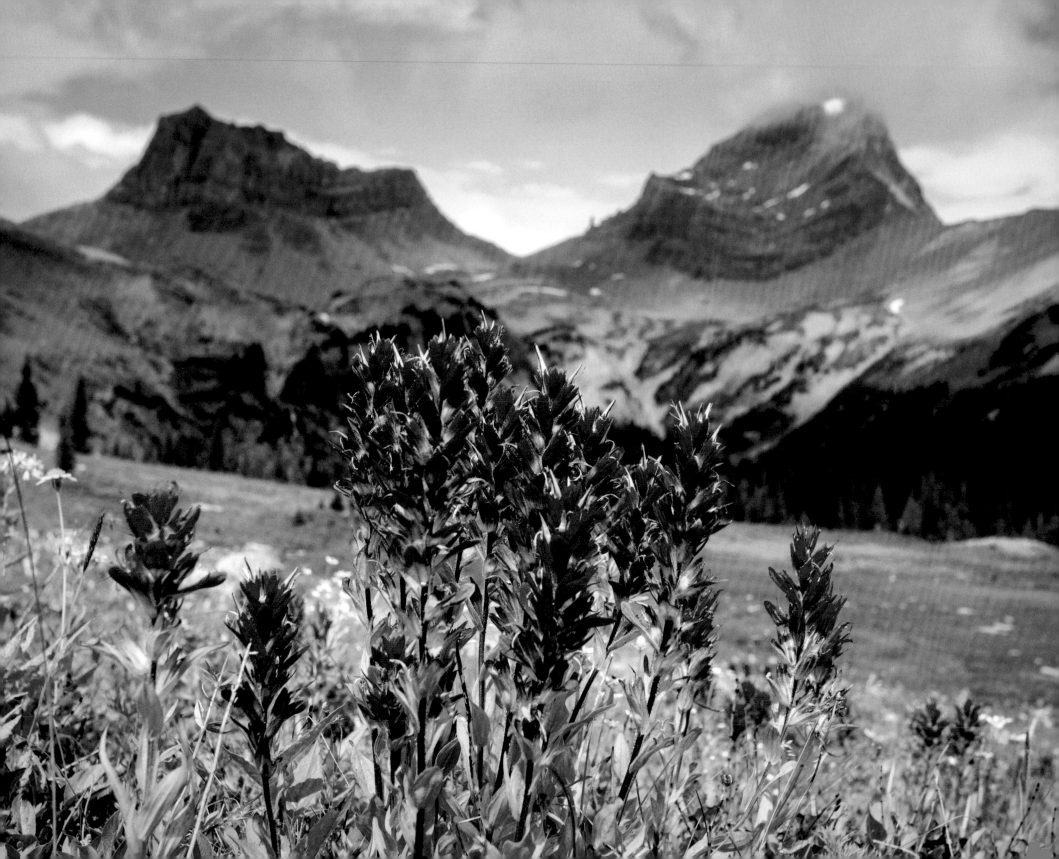

BEAUTY
of the
CANADIAN ROCKIES

RMB

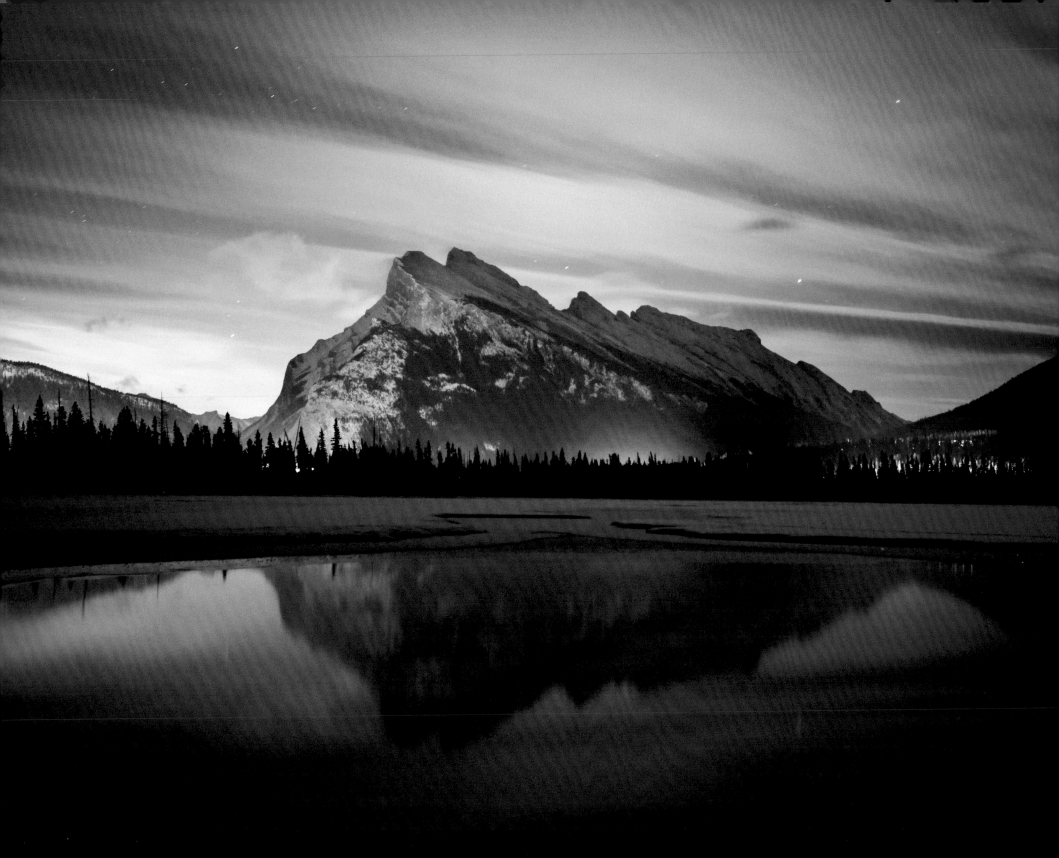

INTRODUCTION

Few places on the planet boast the unique combination of qualities that the Canadian Rockies region is known for. It is here on the Alberta–British Columbia border that ancient ice clings to mountainsides and rivers flow through tree-filled valleys, that rugged peaks meet meadows brimming with wildflowers and wildlife abounds even at the highest elevations. In winter, rivers and lakes freeze to a standstill and a blanket of snow quiets the landscape. The seasonal changes are as dramatic as the dynamic skies that dance above the peaks.

The beauty of the Canadian Rockies is unparalleled and, for over 130 years, visitors have come from around the world to see the magnificent scenery of this UNESCO World Heritage Site. Beauty like this inspires artists and fuels the dreams of adventurers. It beckons people to leave the city life behind and put down roots in a place that sparks creativity and a connection with the wilderness.

The subtle glow of the town of Banff lights up the lower flanks of Mt. Rundle from one of Banff National Park's most photogenic locations, Vermilion Lakes.

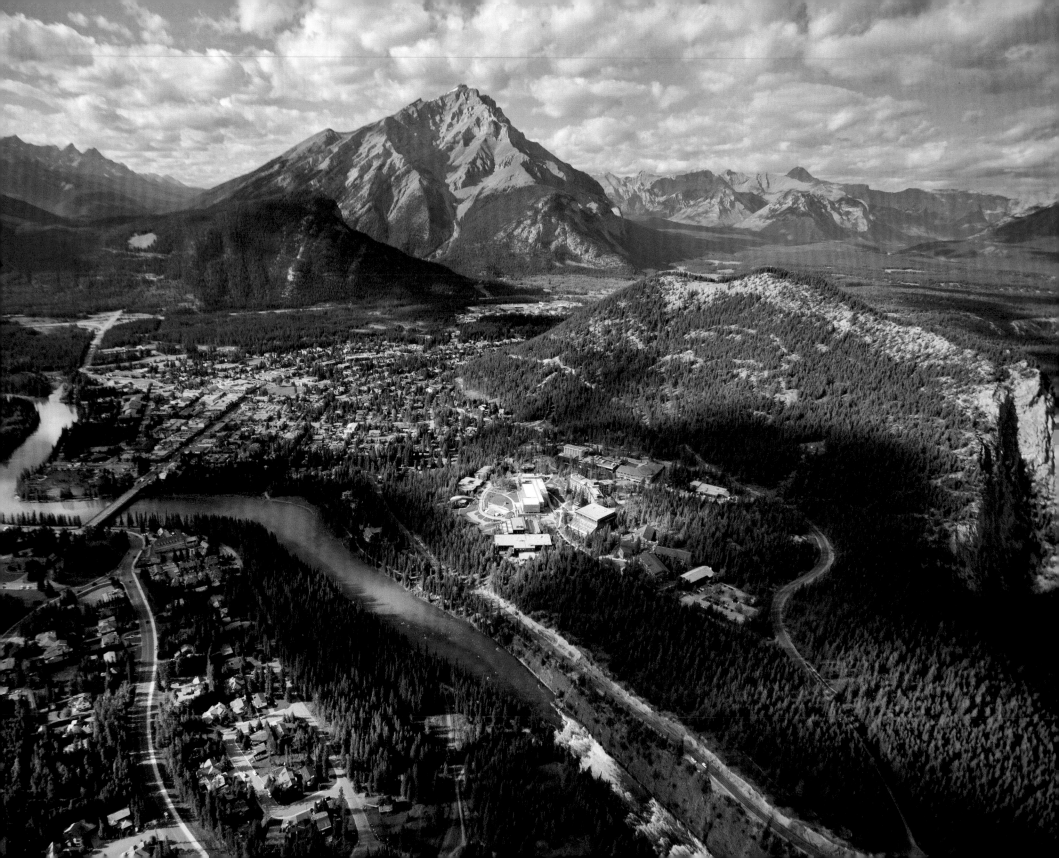

This collection of images demonstrates the allure of this remarkable mountain range. From mountain lakes of every shade of blue to iconic peaks in pristine settings, take a journey through awe-inspiring landscapes and impressive landmarks of the Canadian Rockies. Whether you are on a brief visit or call the mountains home, Beauty of the Canadian Rockies invites you to explore and let nature be your guide.

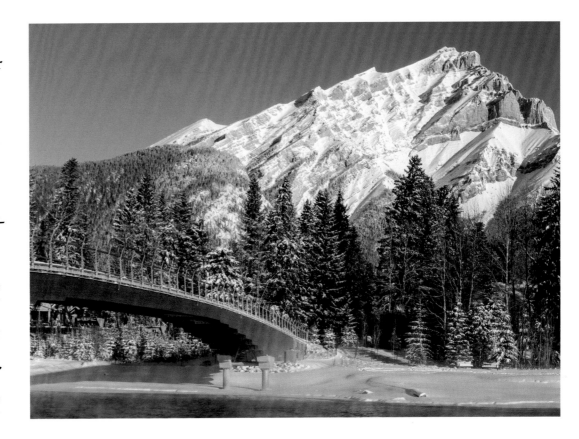

ABOVE *A layer of fresh snow dusts Cascade Mountain and the banks of the Bow River near Banff's pedestrian bridge.*

OPPOSITE *The Bow River snakes its way through the town of Banff. When the townsite was laid out in 1886, superintendent George Stewart oriented the town's main street so that it offered a perfect view of Cascade Mountain.*

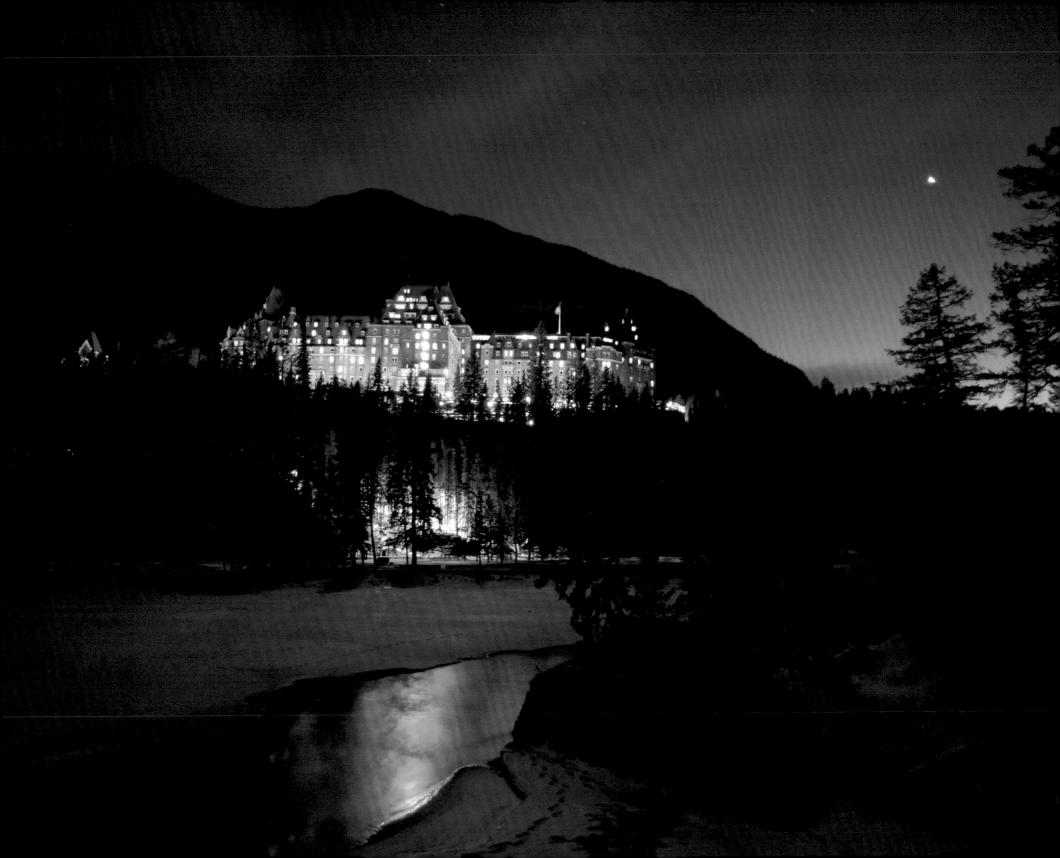

RIGHT *Hoodoos, like these in Banff National Park, are geological formations composed of relatively soft rock covered by harder, less easily eroded rock. Over time, the elements have worn away the surrounding rock, leaving behind these oddly shaped columns.*

OPPOSITE *Now a Fairmont property, the Banff Springs Hotel was constructed as part of CPR vice-president William Cornelius Van Horne's grand plan to build luxurious railway hotels throughout the Canadian Rockies. A National Historic Site of Canada, the hotel was the largest in the world when it first opened in 1888, and has since hosted many dignitaries and celebrities.*

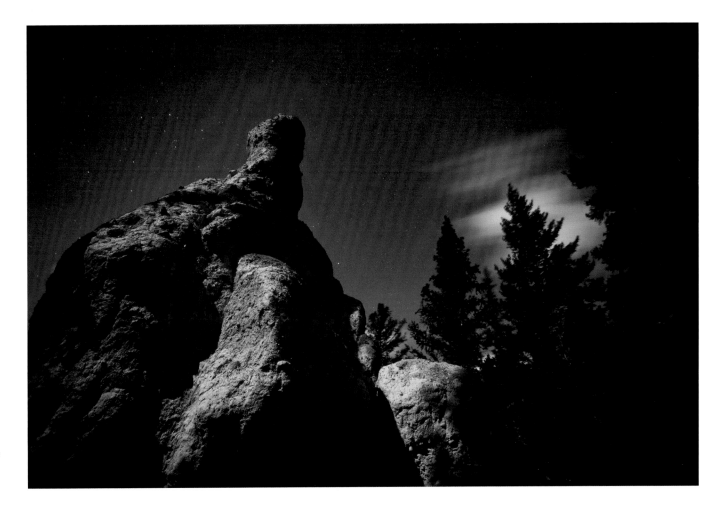

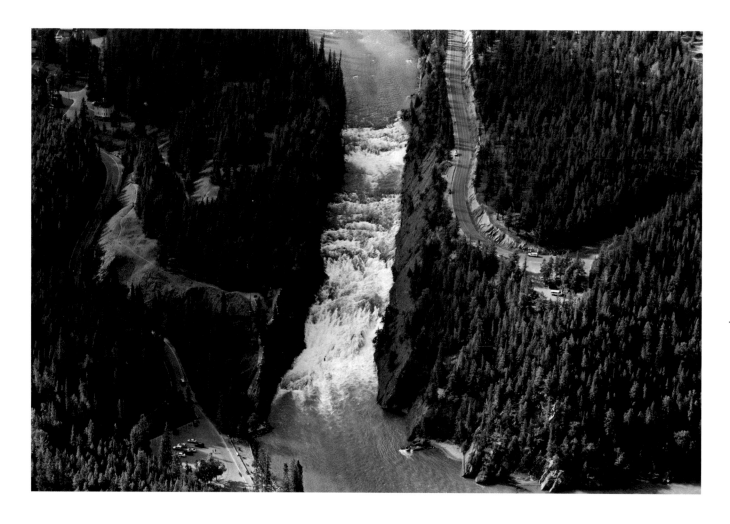

LEFT *This aerial photo of Bow Falls offers a unique perspective of the surging waterfall, which cascades towards the confluence of the Bow and Spray rivers.*

OPPOSITE *The Stoney called the Bow River Minisniwapta, which means "cold water moving fast." No matter how fast it moves, however, the river's flow is brought to an icy halt when winter descends on the region.*

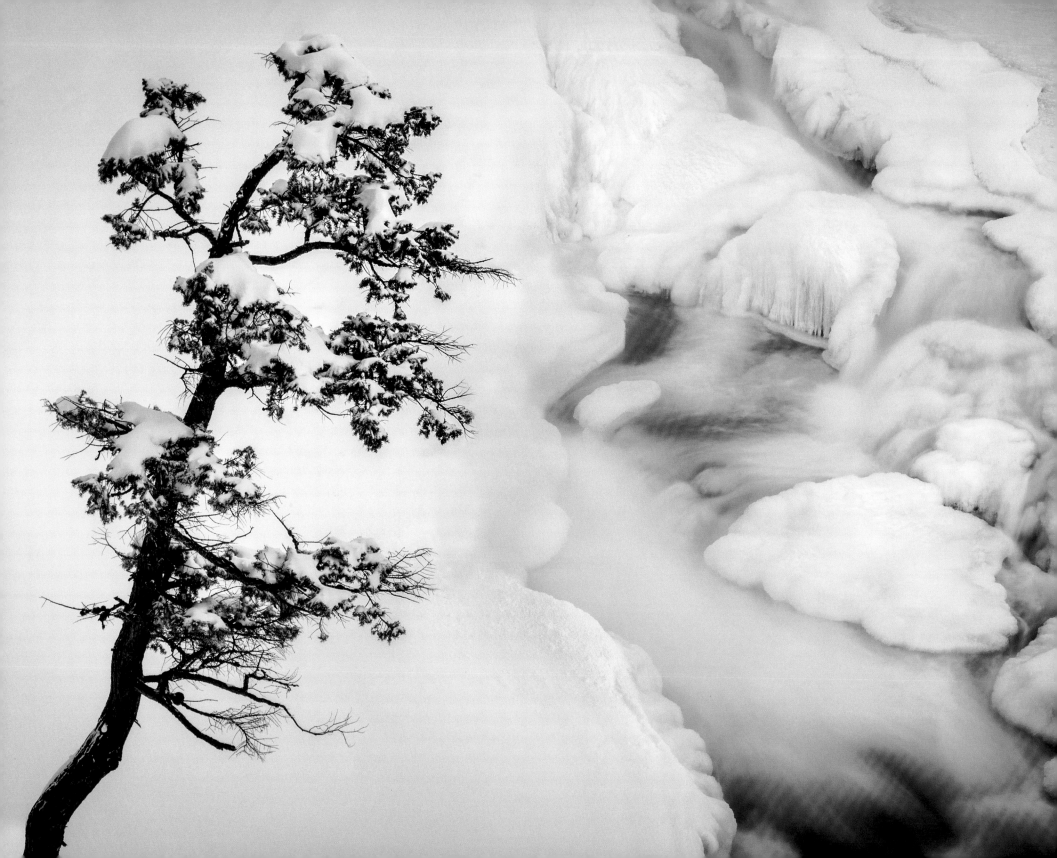

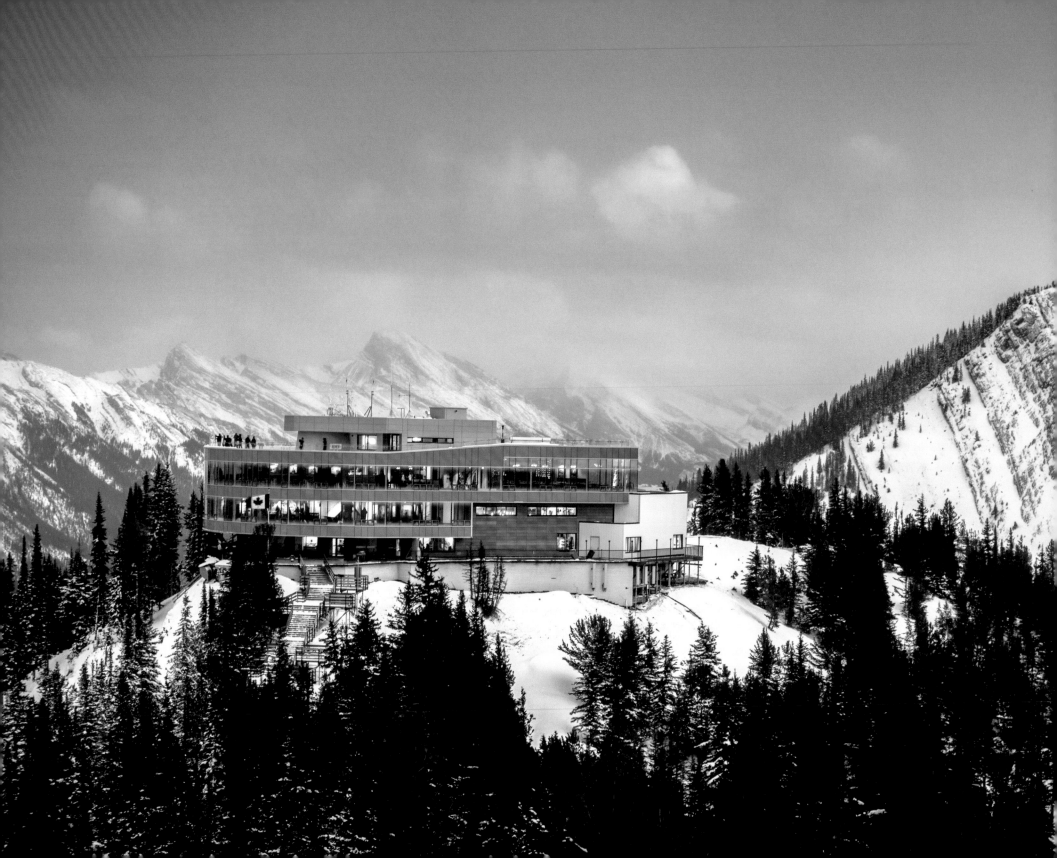

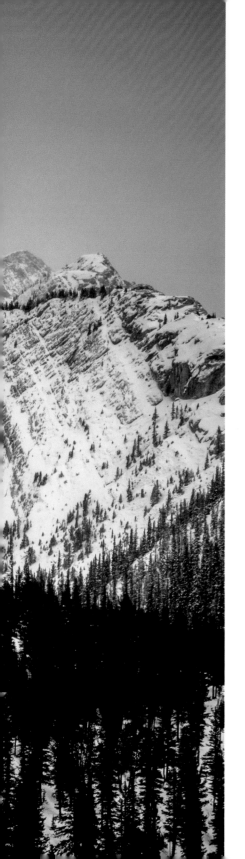

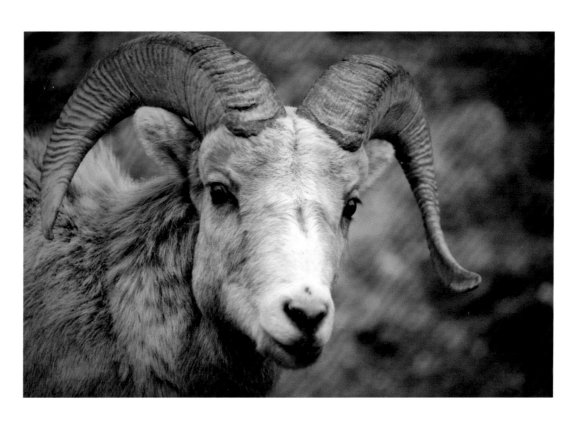

ABOVE *Easily recognized for their curved horns (in males), the Rocky Mountain bighorn sheep are wonderful to look at but a force to be reckoned with. Large males can weigh up to 500 pounds!*

LEFT *The Sulphur Mountain Gondola climbs 700 metres up the side of its namesake peak to an upper terminal, a state-of-the-art venue featuring interpretive displays, a gift shop and restaurants with the best views in the Banff region.*

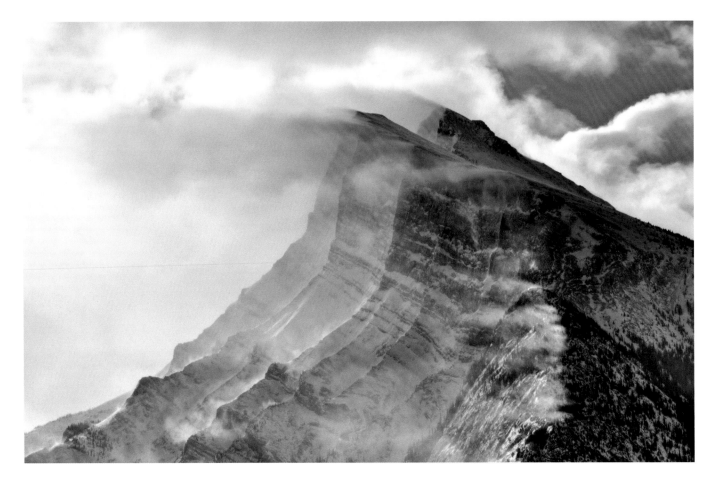

LEFT *Snow drifts from the wind-scoured, serrated peaks of the 2948-metre-high Mt. Rundle. The Cree name was Waskahigan Watchi, which means "house mountain." In 1858 John Palliser named the mountain after Reverend Robert Rundle, a Methodist minister who had come to the Bow Valley as a missionary in the 1840s.*

OPPOSITE *Night falls over the peaceful town of Banff, nestled at the confluence of three river valleys – the Spray, the Bow and the Cascade. This image, taken from the lower flanks of Mt. Norquay, shows the town's idyllic setting.*

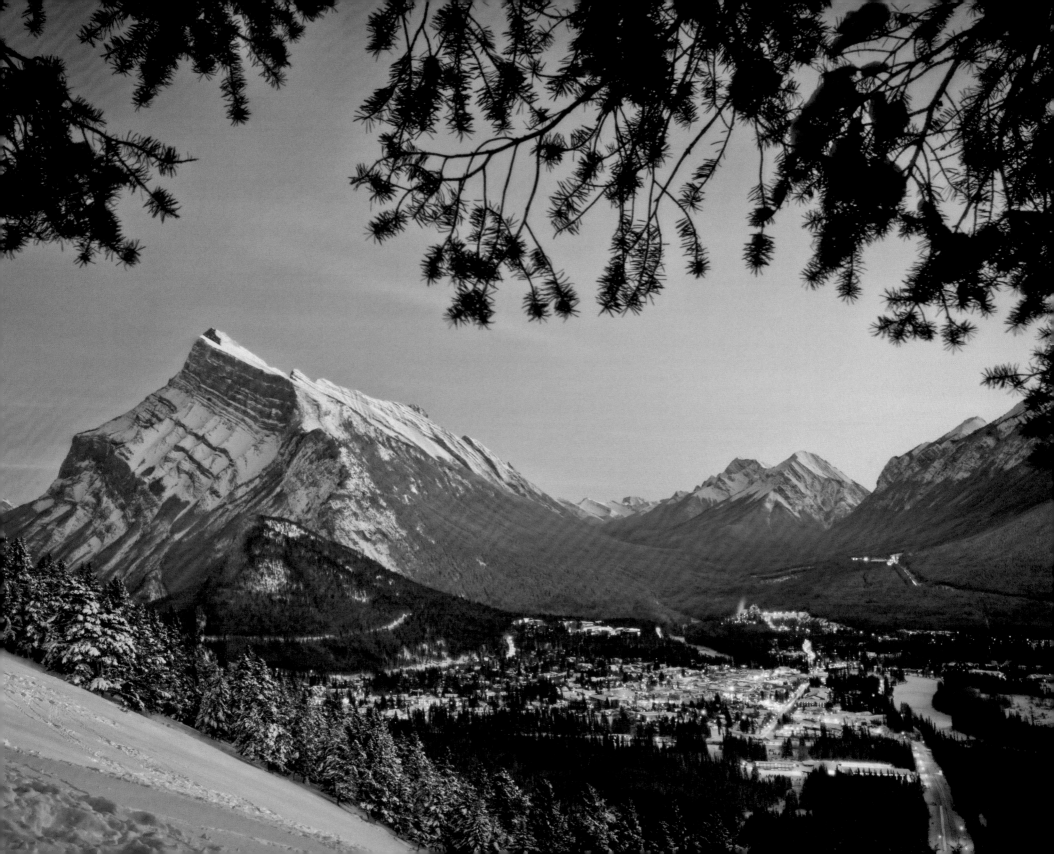

Lake Minnewanka (Stoney for "water of the spirits") is flooded with history – literally. Now the largest lake in Banff National Park, Minnewanka has been dammed twice, and in 1941 submerged a town called Minnewanka Landing. The waters are said to be haunted, hence the name. It is one of the only lakes in the Canadian Rockies that allows for commercial motorized boats; the Lake Minnewanka Boat Cruise (pictured here at centre) provides views of the surrounding peaks.

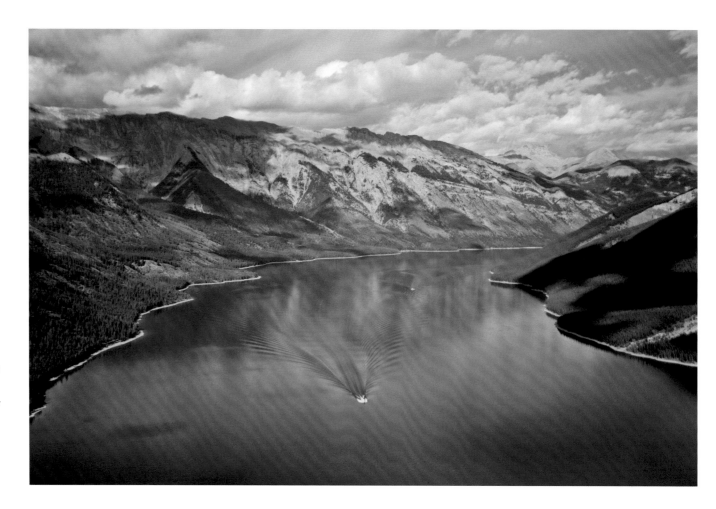

Thanks to the dark skies of Banff National Park, the aurora borealis, or northern lights, can frequently be seen from areas with north-facing views, such as Lake Minnewanka.

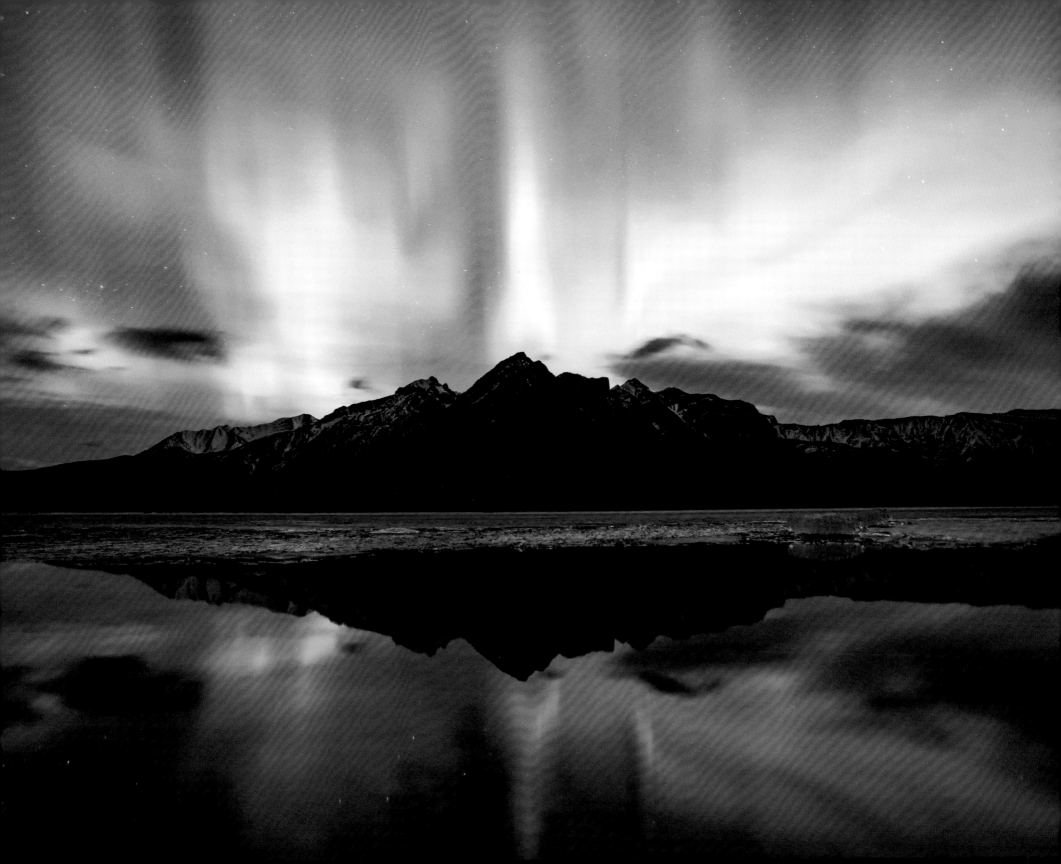

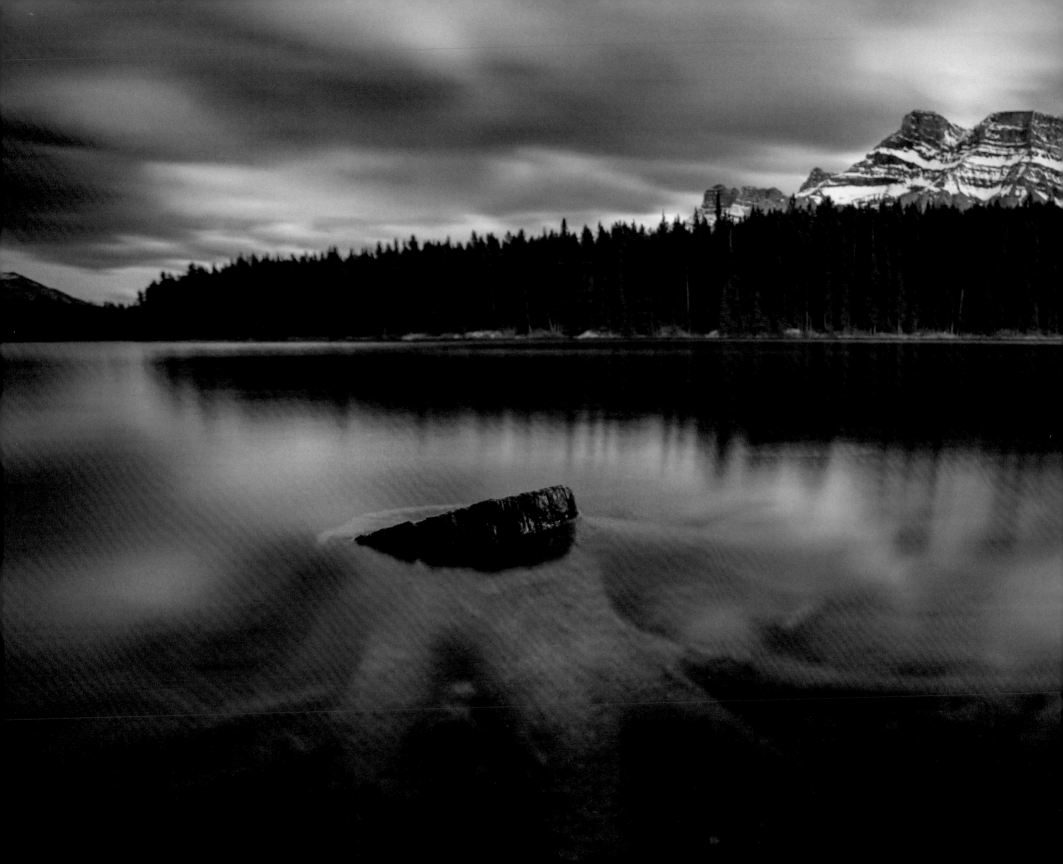

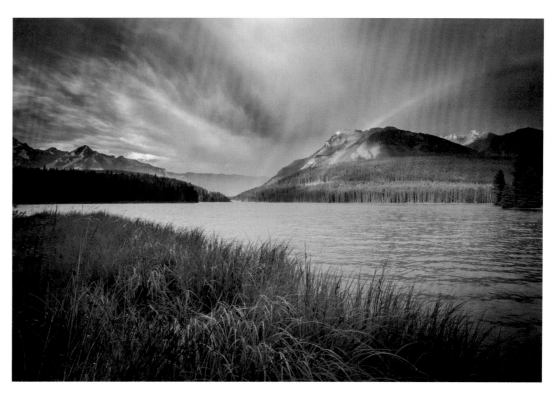

ABOVE *A double rainbow graces the sky at Two Jack Lake, named after two men who lived and worked in the Banff area in the early 20th century: Jack Standly, the boat operator at Lake Minnewanka, and Jack Watters, who worked in the mines at nearby Bankhead.*

LEFT *Evening sets in at Johnson Lake. This popular recreational area close to the town of Banff offers hiking, swimming and paddling in summer and, if you get there when the conditions are right, a memorable skating rink in wintertime.*

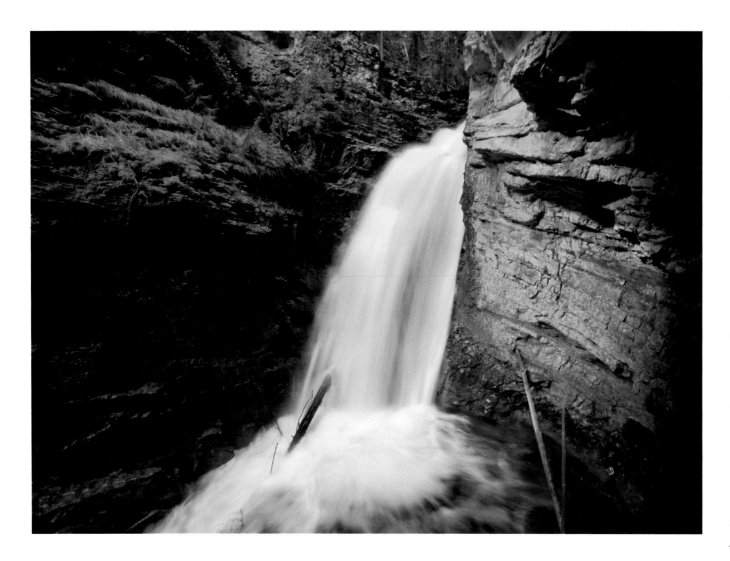

LEFT *At Johnston Canyon, one of the most popular locations in Banff National Park, you can hike interpretive walkways – some built right into the canyon walls – to the base of two waterfalls, the Upper and Lower Falls, pictured here.*

OPPOSITE *Morant's Curve is a favourite spot for photographers looking to capture an image of a train passing through this scenic location in the Bow Valley. It is named after a photographer who did just that: Nicholas Morant took photos for the CPR in the mid-20th century. Many of his images used in the company's promotional materials featured this very spot.*

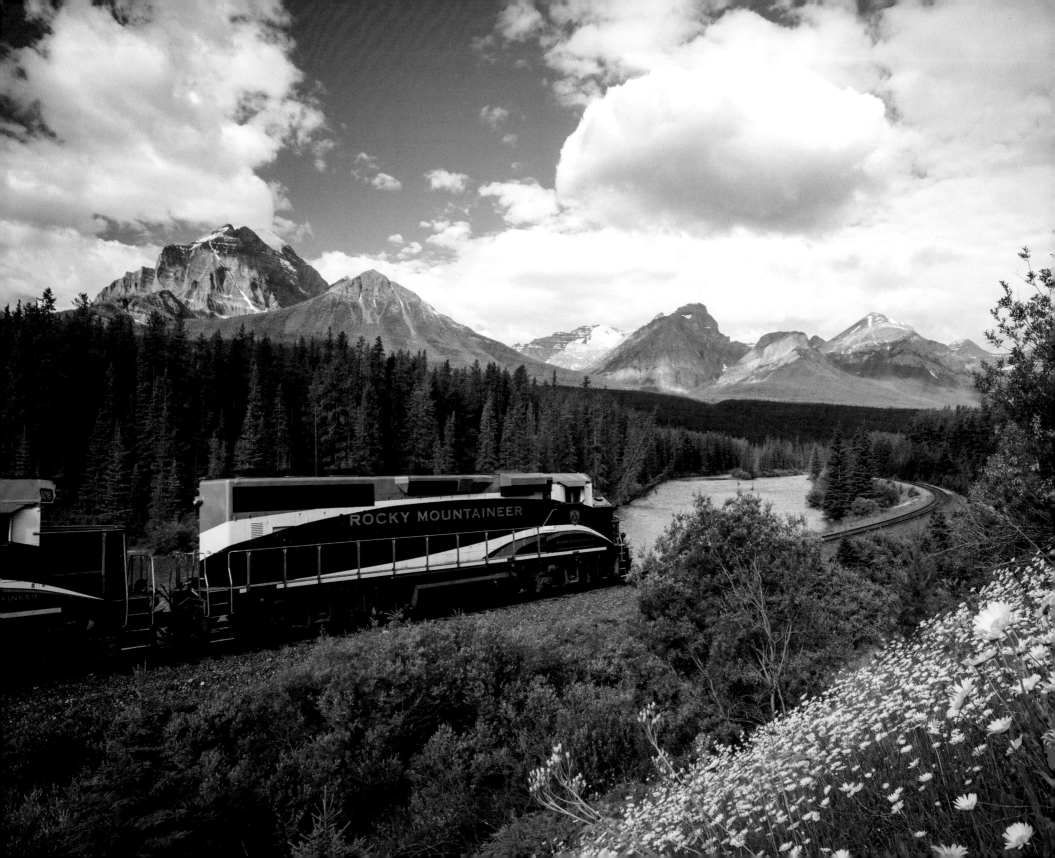

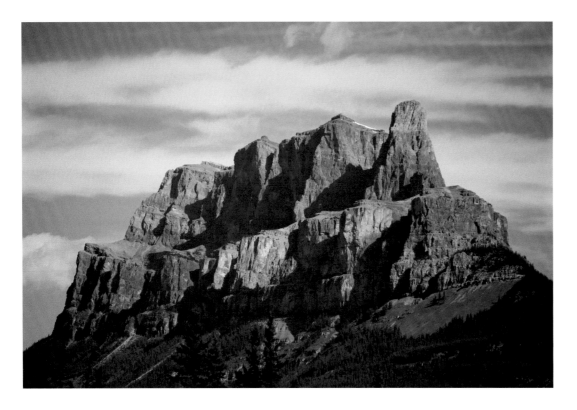

ABOVE *Named for its shape, 2766-metre-high Castle Mountain was formed as weak layers of shale eroded over the course of centuries, leaving behind more resistant limestone towers. In 1946, its name was changed to Mt. Eisenhower, in honour of the American general. The original name was restored in 1979 due to public pressure, though one of its pinnacles was named Eisenhower Tower.*

RIGHT *An eagle soars amidst the rocky peaks at Taylor Lake, Banff National Park.*

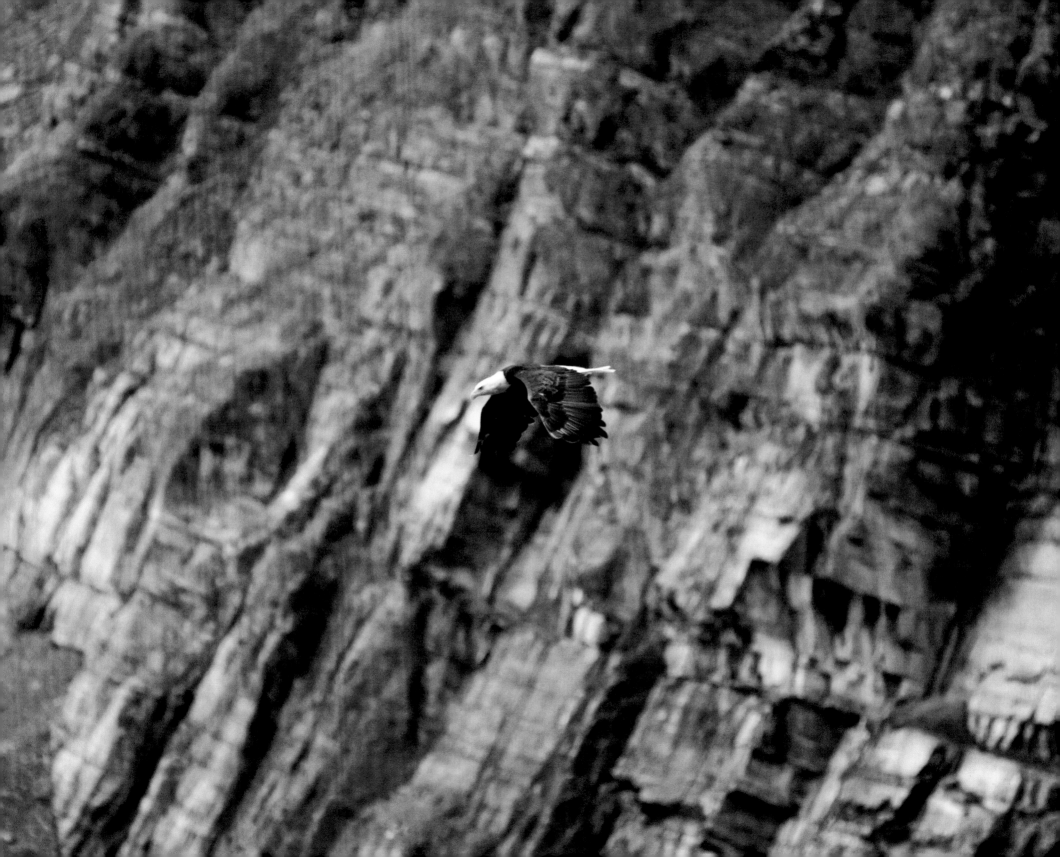

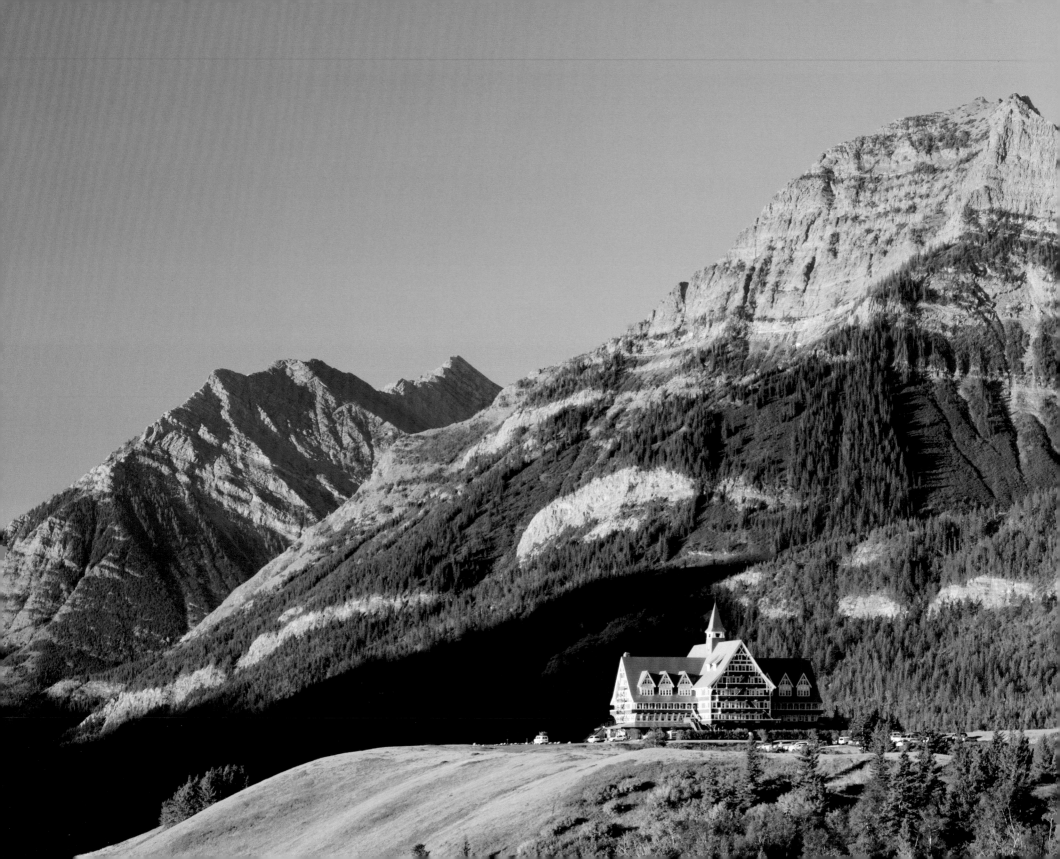

OPPOSITE The Prince of Wales Hotel in Waterton Lakes National Park has an illustrious placement on a hillside overlooking Upper Waterton Lake. Unlike any other grand railway hotel in the Canadian Rockies, the Prince of Wales was built by an American railway, the Great Northern, in 1926–27, as a stop for affluent travellers en route to nearby Glacier National Park. It was designated a National Historic Site in 1995.

RIGHT Elk, or wapiti, are large ungulates native to the Canadian Rockies. Each spring, the males grow antlers – some nearly four feet long – which are shed in winter.

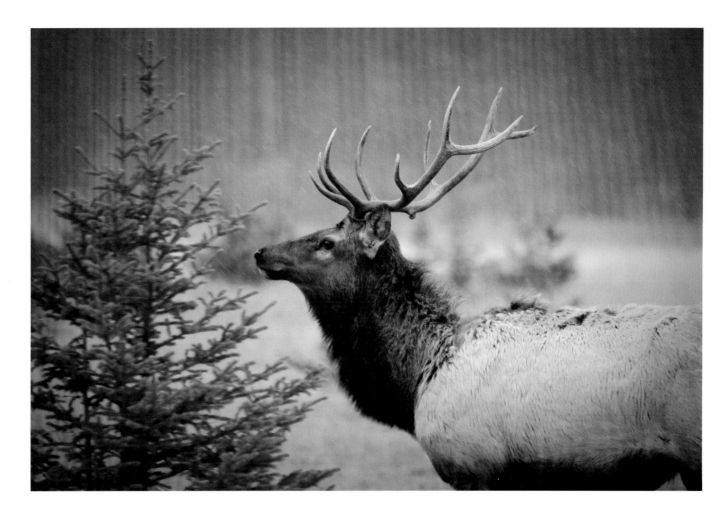

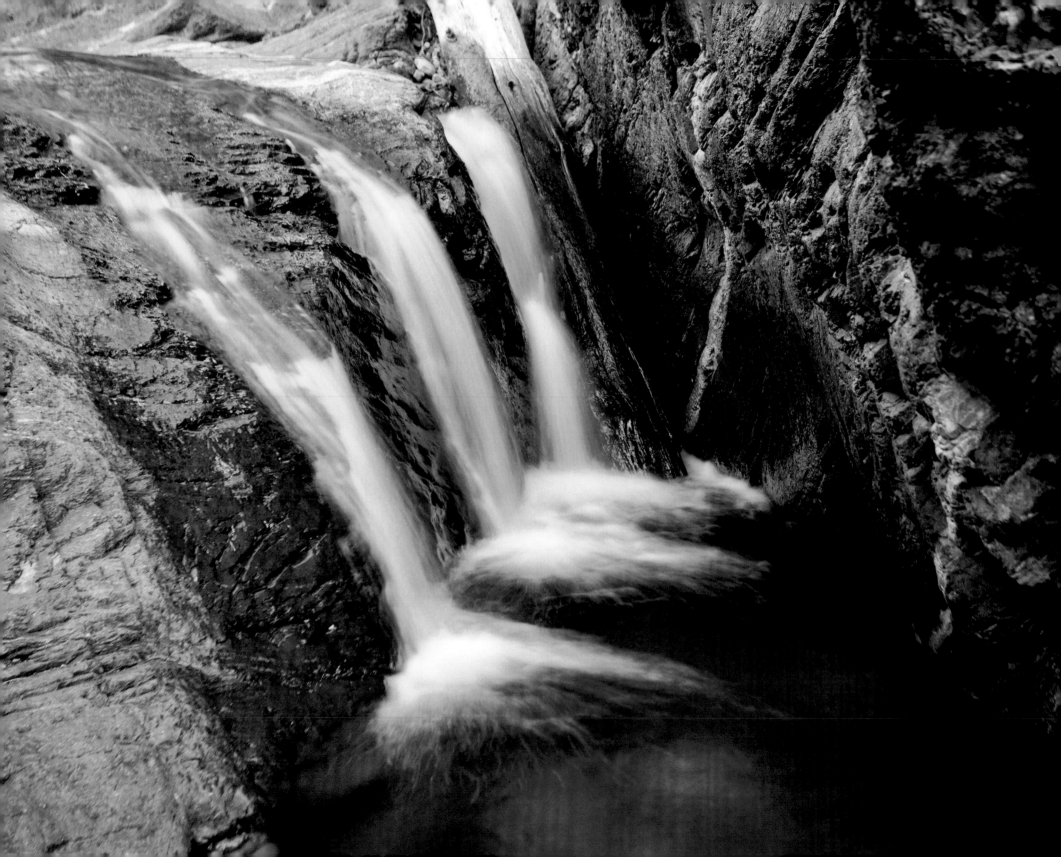

OPPOSITE Red Rock Canyon is one of the most striking features in Waterton Lakes National Park. Its colour comes from iron-rich shales that, when oxidized, turn a bright shade of red.

RIGHT Nicknamed the "Matterhorn of the Rockies" for its resemblance to the iconic peak in the Alps, Mt. Assiniboine (3618 metres) is the highest peak in the southern Canadian Rockies. It was named in 1885 by George Dawson, who was inspired by the plume of cloud often seen floating off the summit, which reminded him off the smoke coming from the teepees of the Assiniboine people.

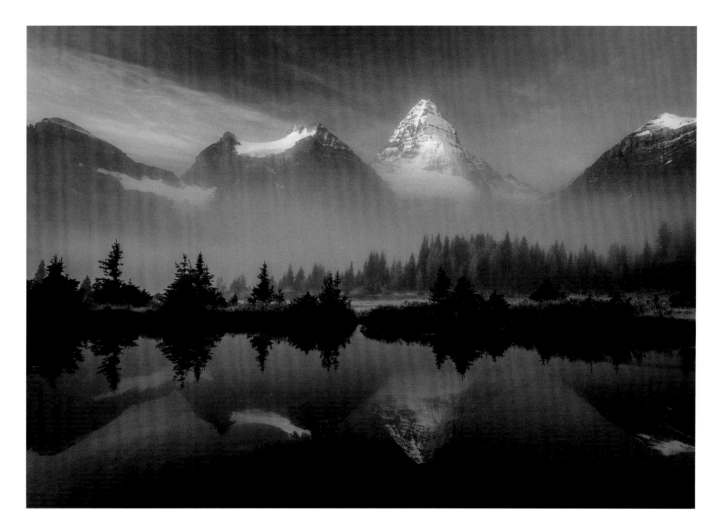

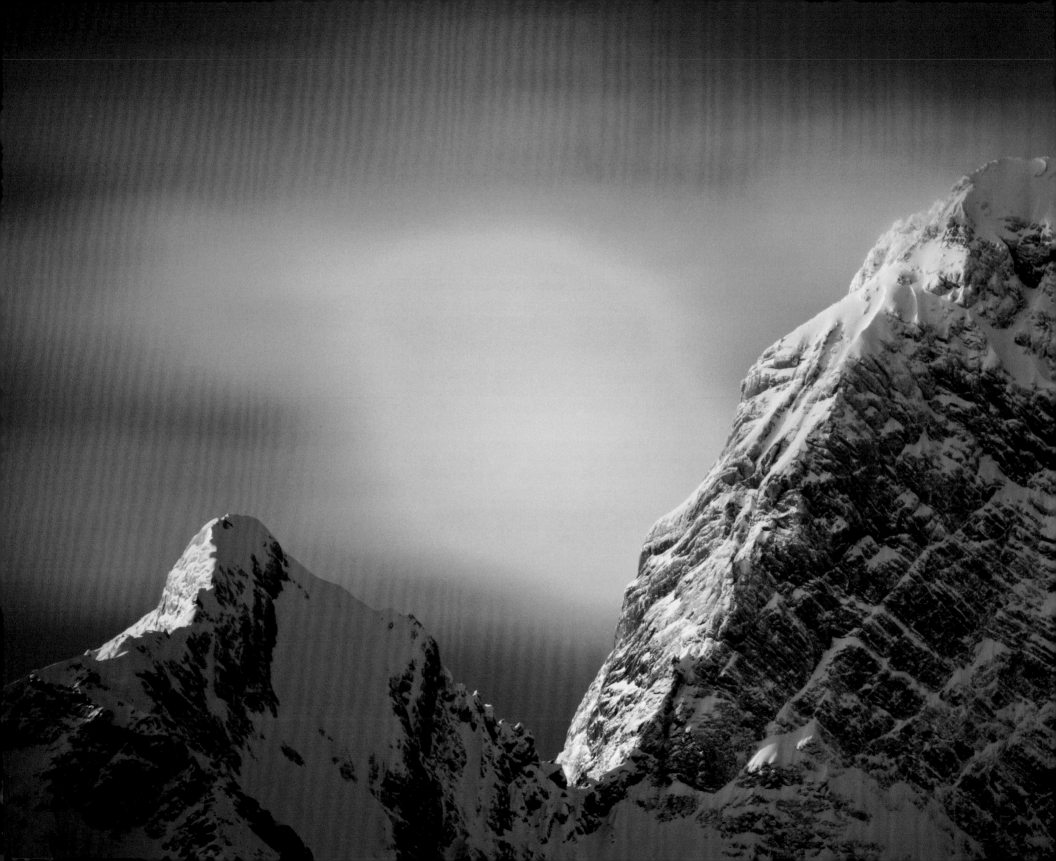

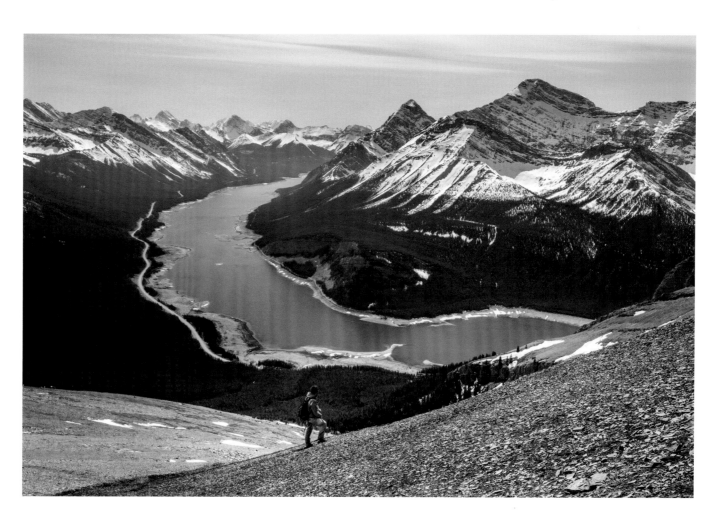

LEFT *An alpenglow illuminates the shoulder of Mt. Birdwood, a prominent peak that sits on the border of Kananaskis Country and Banff National Park.*

ABOVE *A hiker overlooks the Spray Lakes Reservoir in Kananaskis Country. Once a string of lakes formed along the Spray River, the Spray Lakes Reservoir was created when the river was dammed, uniting them.*

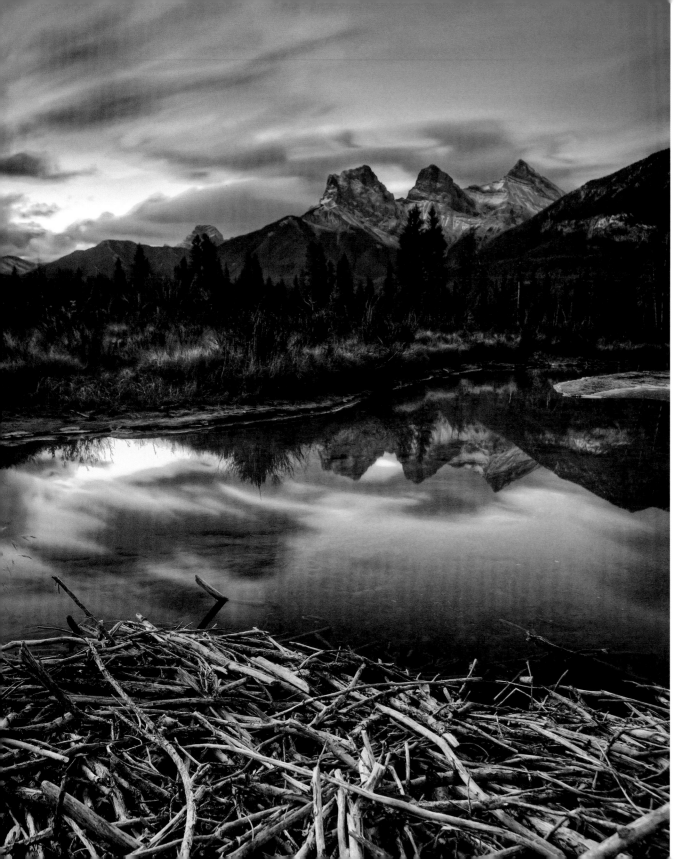

LEFT *The Three Sisters, near Canmore, were named by Albert Rogers in 1883. When he awoke in his tent after a heavy snowstorm, he looked up at the peaks and thought they looked like three nuns; subsequent maps changed "nuns" to "sisters." The peaks are known individually as Faith (Big Sister), Hope (Middle Sister) and Charity (Little Sister).*

RIGHT *Evening sets in at Mt. Engadine Lodge. Built in 1987, this unique mountain lodge is the only one of its kind in Spray Valley Provincial Park.*

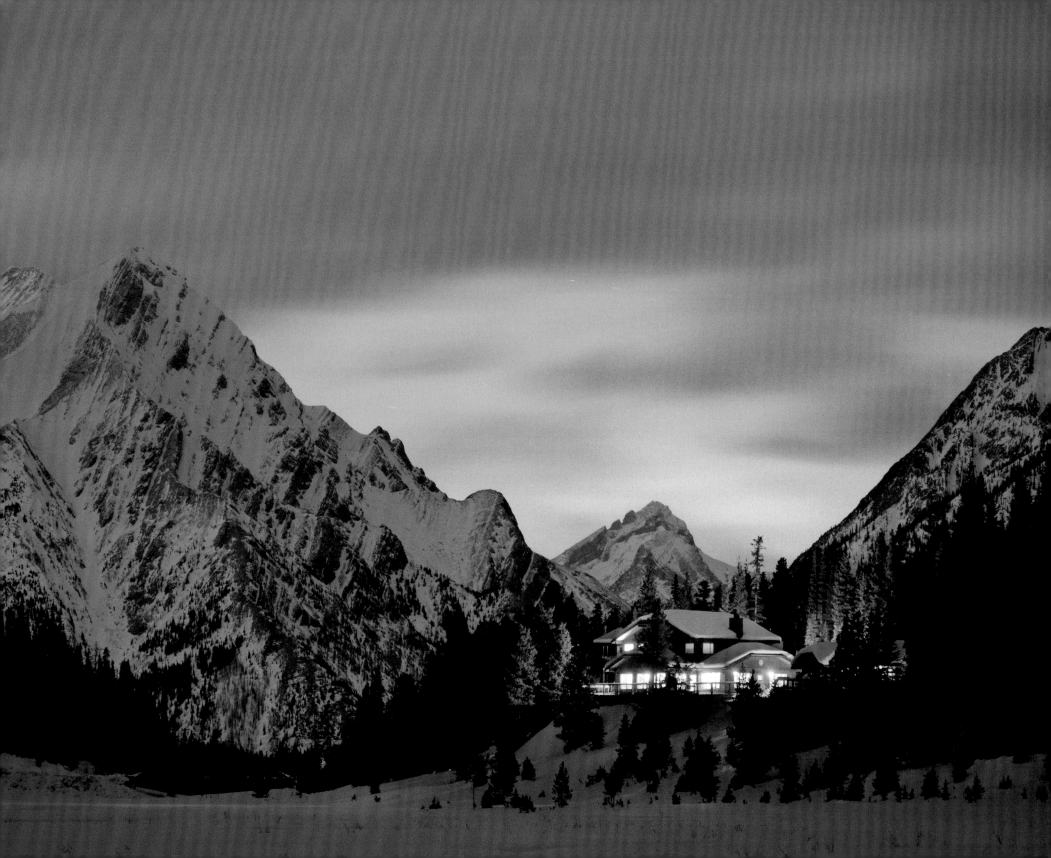

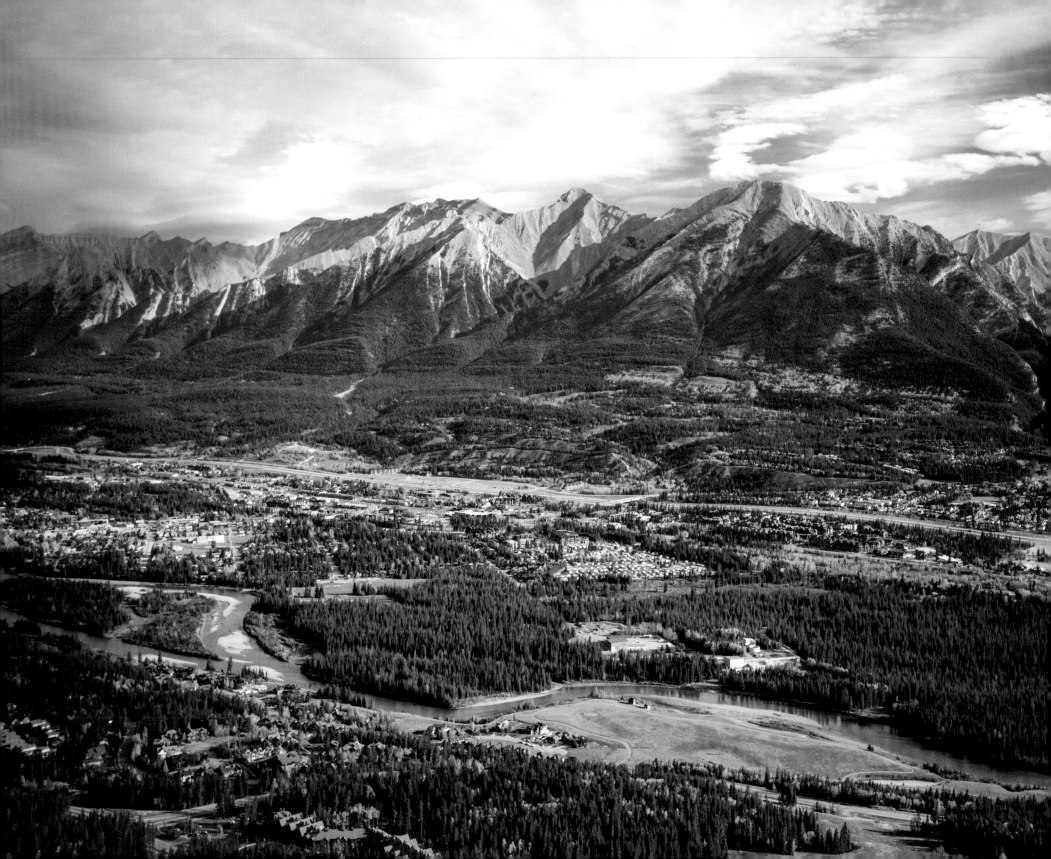

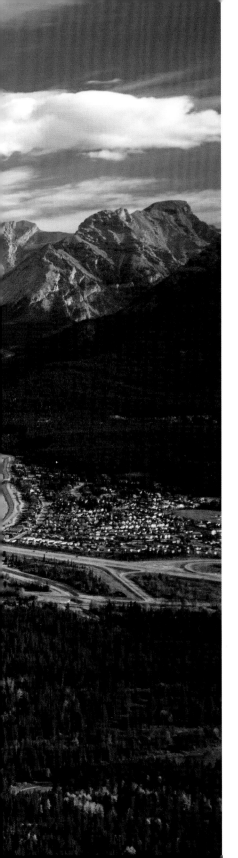

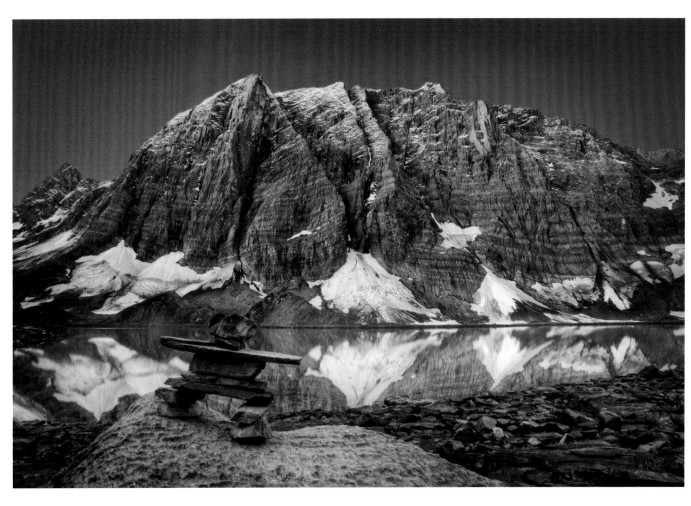

LEFT *The town of Canmore boasts an enviable location in the Bow Valley and provides quick access to world-class hiking, mountain biking and cross-country ski trails.*

ABOVE *A classic of Kootenay National Park, the hike to Floe Lake (pictured here) can be done as a longer day trip, or as part of a multi-day backpacking excursion on the Rockwall Trail.*

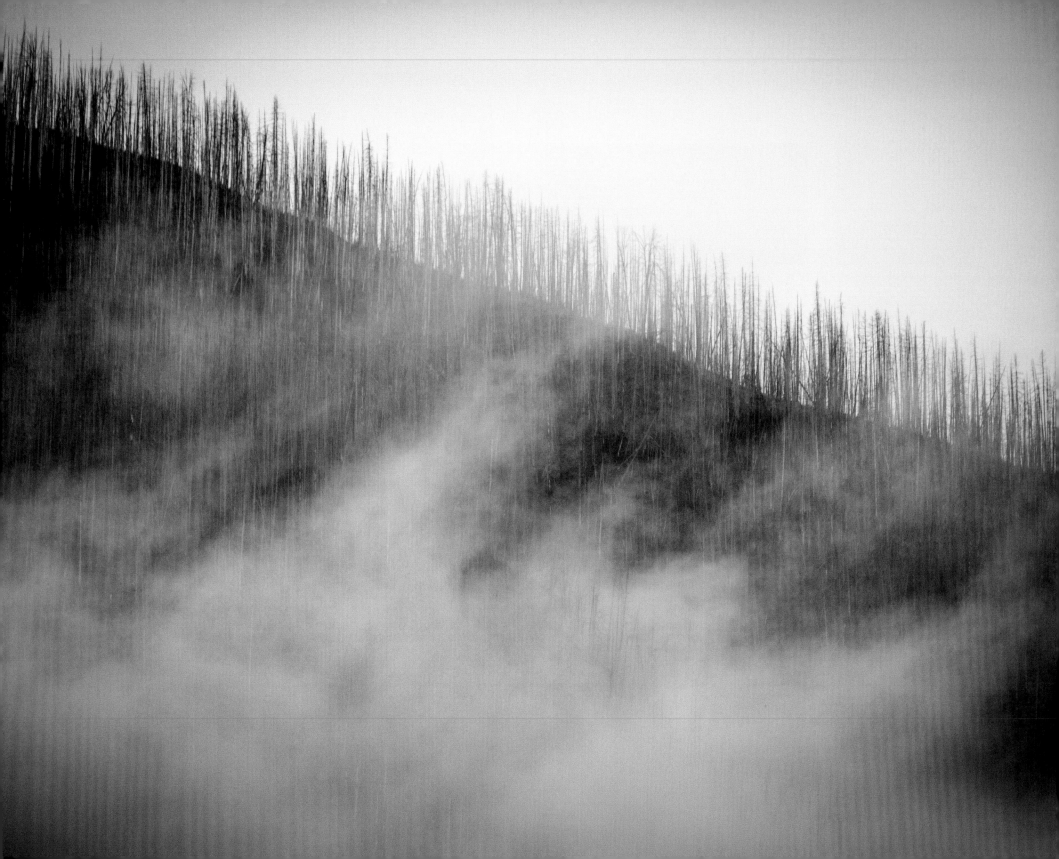

OPPOSITE *Products of the 2003 burn that scarred 17,000 hectares of Kootenay National Park, many forest areas have been reduced to blackened, leafless trees. Even in these burnt areas, keep your eyes peeled for wildflowers growing amidst the charred stumps and deadfall. There is beauty even in a singed forest if you look for it.*

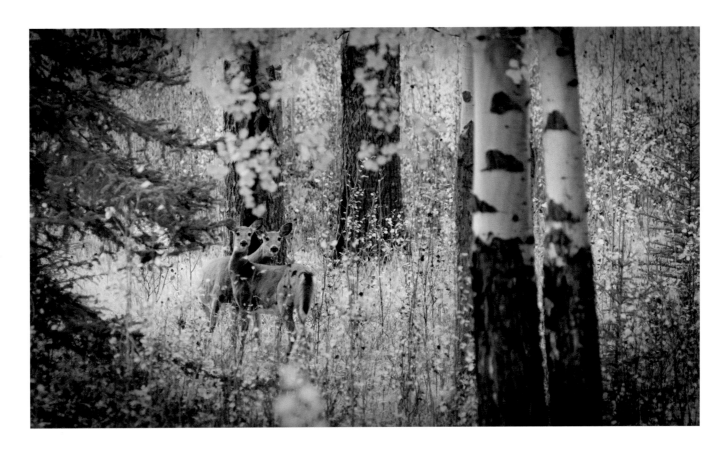

ABOVE *Two mule deer peek through the forest amidst the changing colours of fall.*

35

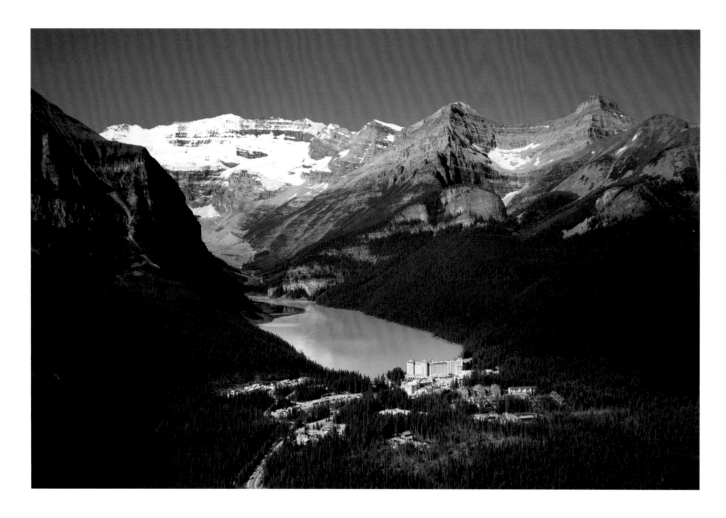

LEFT *Viewed here from the sky, the Fairmont Chateau Lake Louise and surrounding properties can be seen at their enviable lakeside locations. The glaciated peak is Mt. Victoria, named by surveyor J.J. McArthur in honour of Queen Victoria.*

OPPOSITE *Lake Louise is a popular location for sightseeing year-round; in summer, its open waters show a dramatic shade of turquoise.*

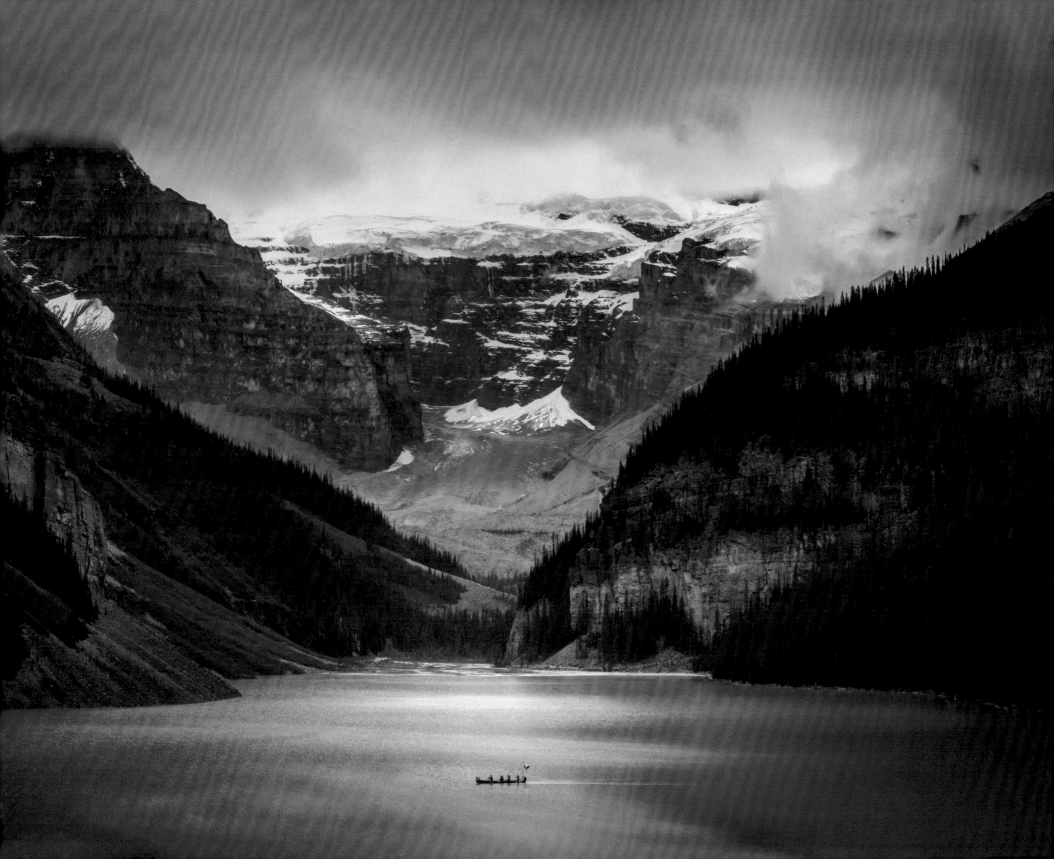

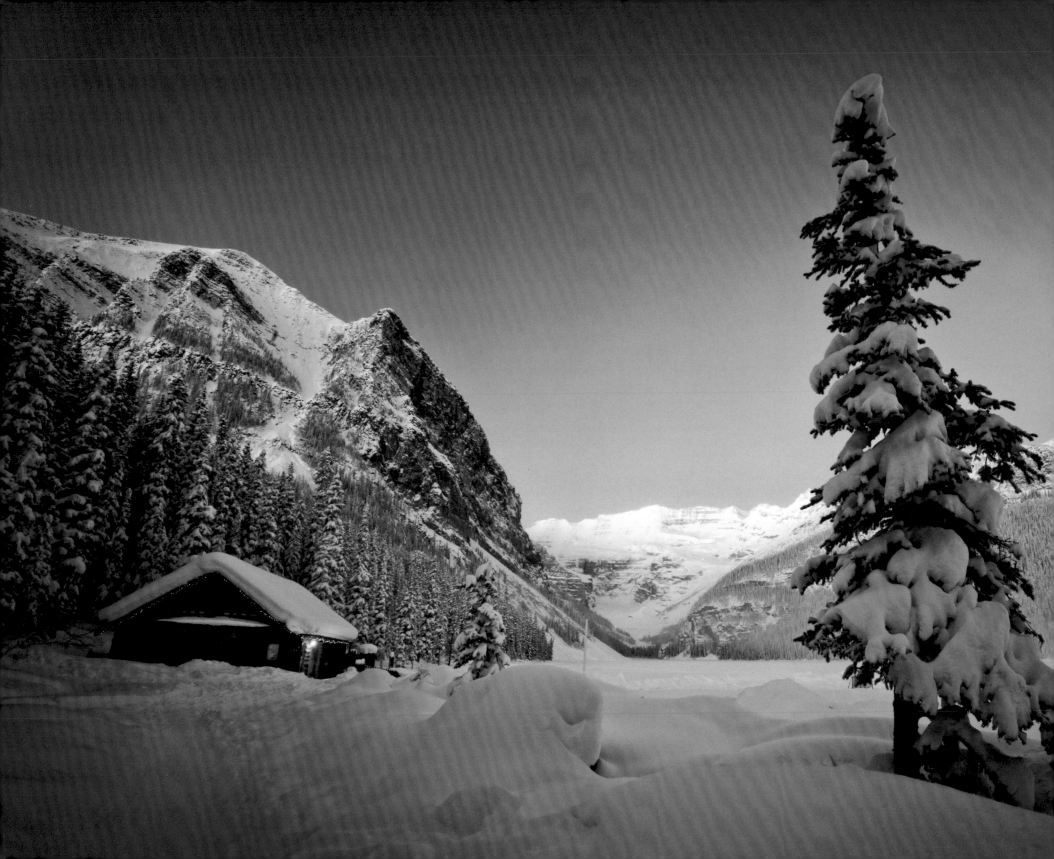

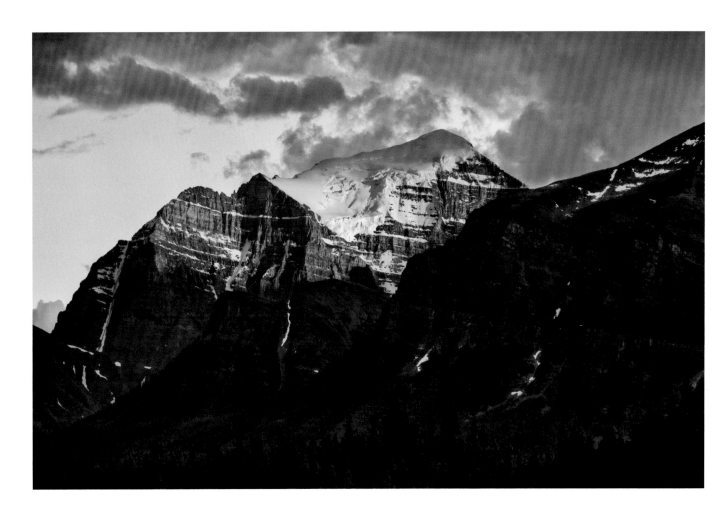

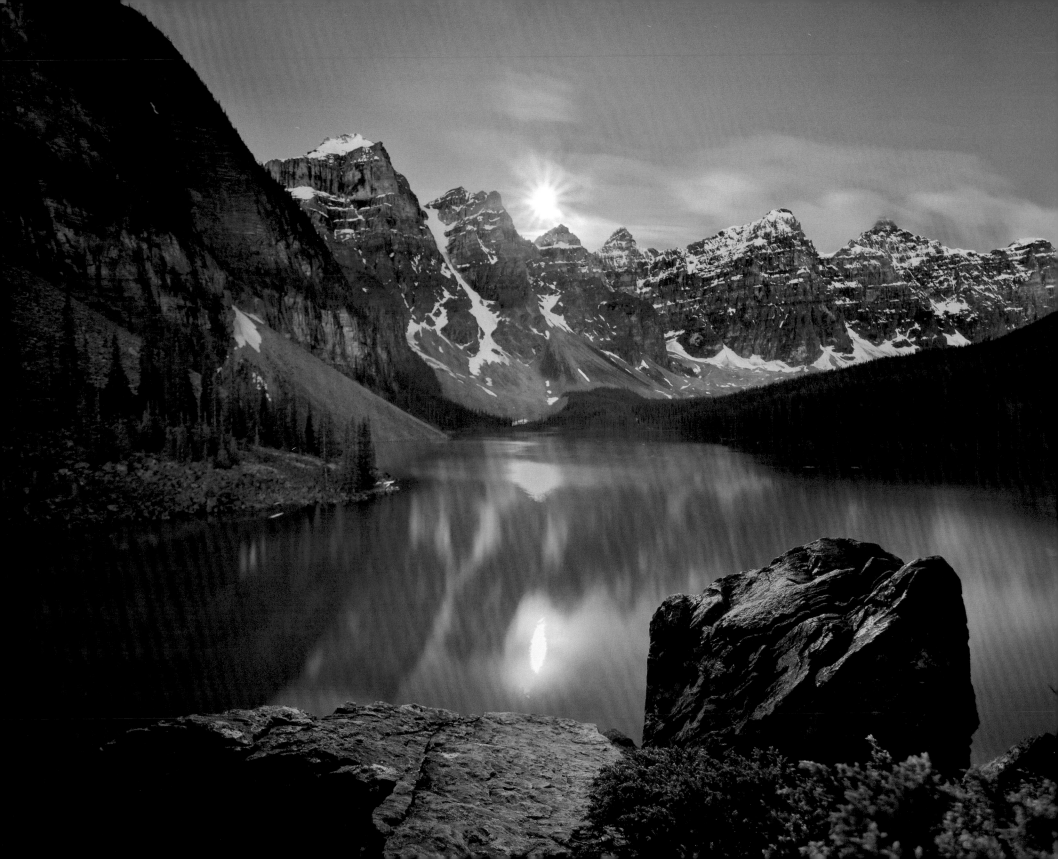

OPPOSITE *The moon rises at Moraine Lake, one of the most well-known locations in the Canadian Rockies. The famous skyline is punctuated by the Ten Peaks, which were once named after the Stoney words for numbers one through ten (now three retain their Stoney names while others have been changed to the names of noteworthy individuals). This view is also known as the Twenty Dollar View, as it once appeared on the back of the $20 Canadian banknote.*

RIGHT *This unusual aerial perspective of Moraine Lake shows its dramatic colour. Lakes throughout the Canadian Rockies are world-famous for their vibrant blue-green hues, which result from glacial silt in the water reflecting those particular colours of light.*

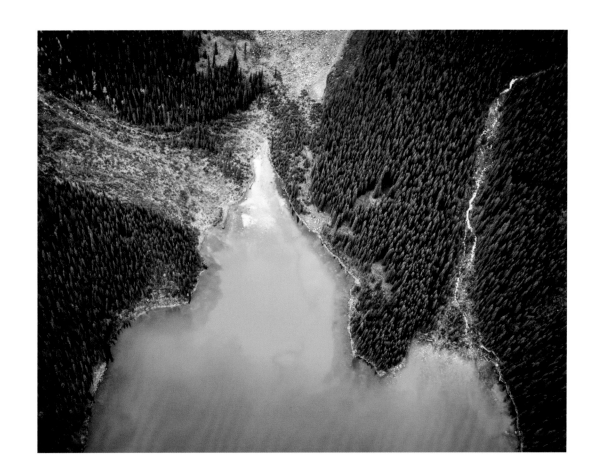

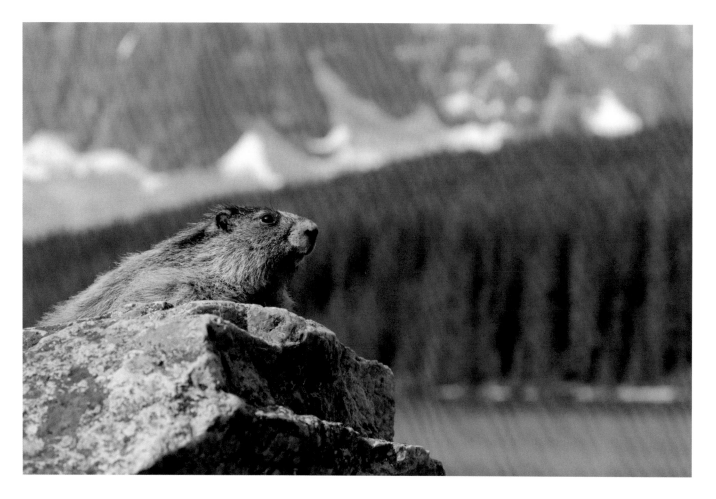

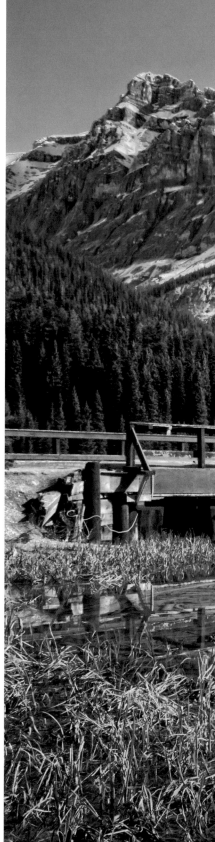

ABOVE *A common resident of alpine regions, the hoary marmot is often heard before it is seen, thanks to its distinctly long and high-pitched whistles.*

RIGHT *Boasting a prime location on the shores of its namesake, Emerald Lake Lodge was originally built in 1902. The lodge has been renovated in the intervening years, but it retains its historic charm and offers visitors a chance to unwind in a pristine setting.*

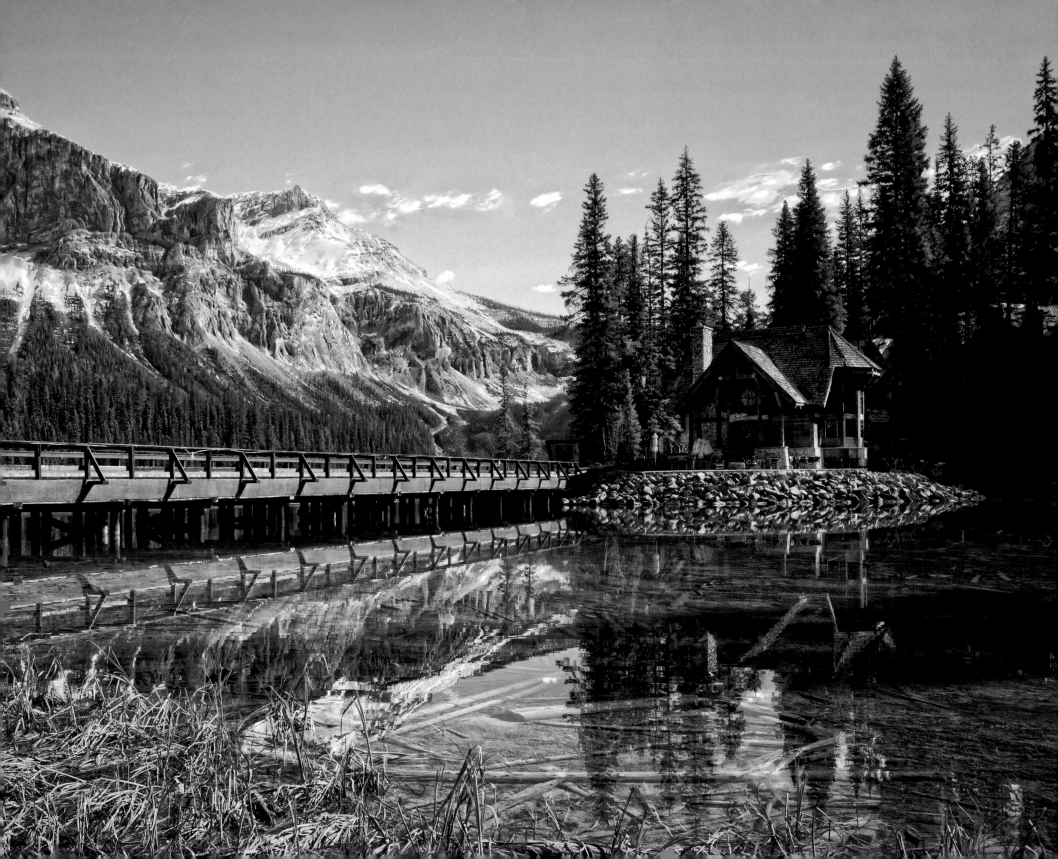

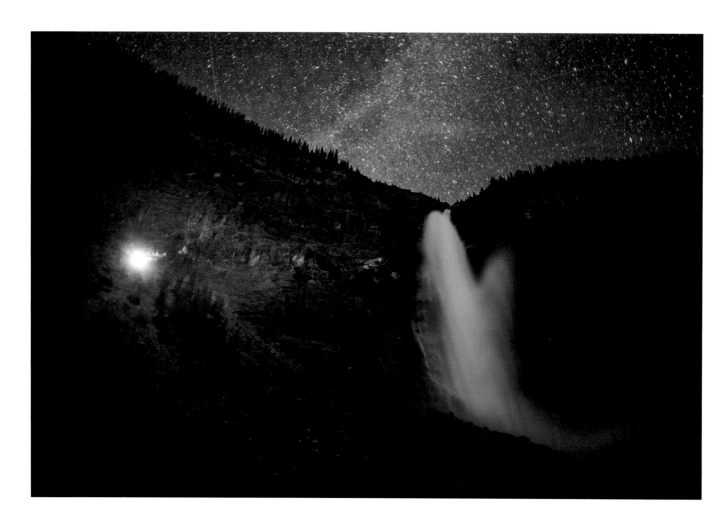

LEFT *Fed by the Daly Glacier above, Takakkaw Falls is one of the higher waterfalls in the Canadian Rockies, at 302 metres. Roughly translated, the name means "it is magnificent" in Cree. Here, climbers do a nighttime ascent of the rock wall to the left of the falls.*

OPPOSITE *Lake O'Hara's shoreline is dotted by the cabins of Lake O'Hara Lodge, and its famous skyline of peaks rises beyond, including Mts. Huber, Victoria, Lefroy, Yukness and Hungabee. Because the lake is accessible only by bus or a 12-kilometre hike or ski in, it is never crowded. The region boasts one of the best hiking trail networks in the Canadian Rockies.*

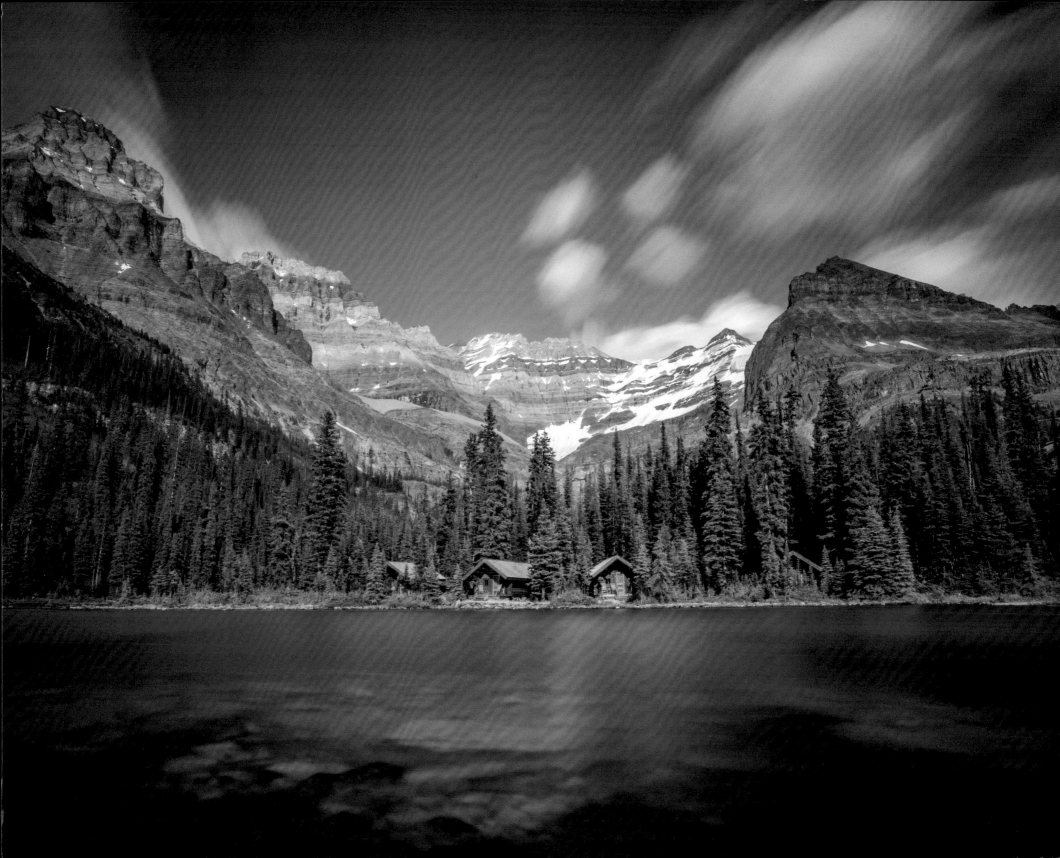

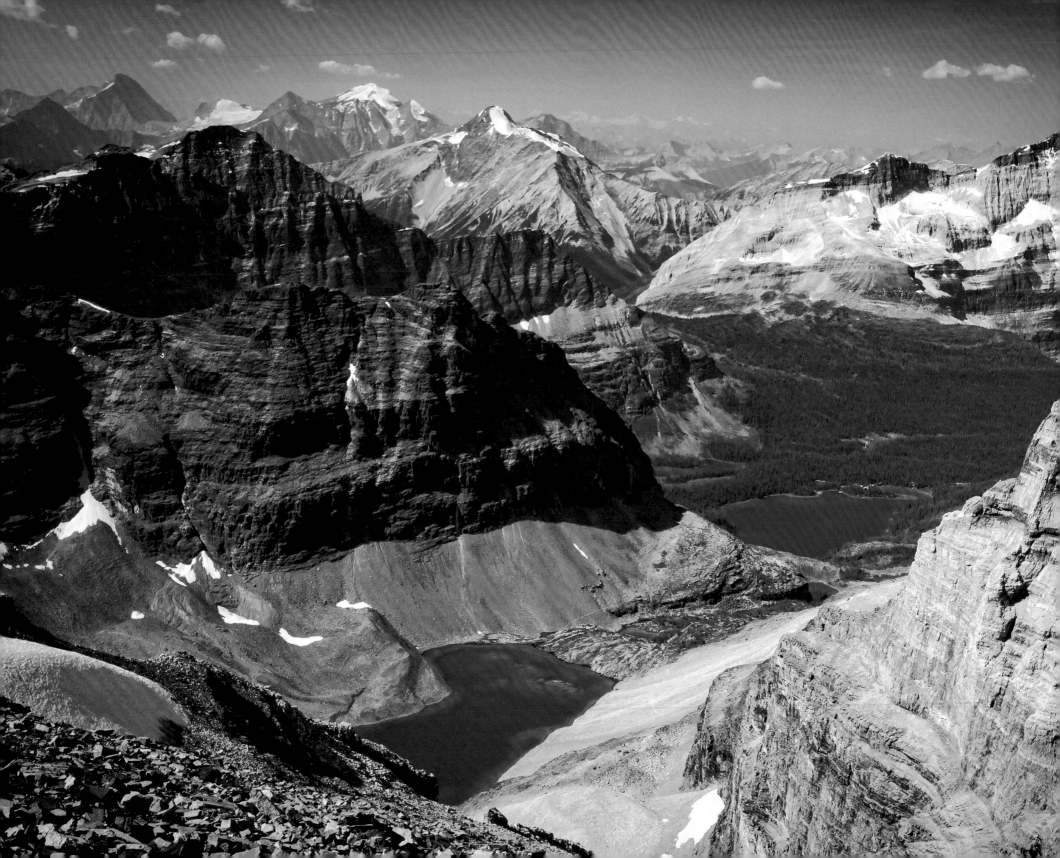

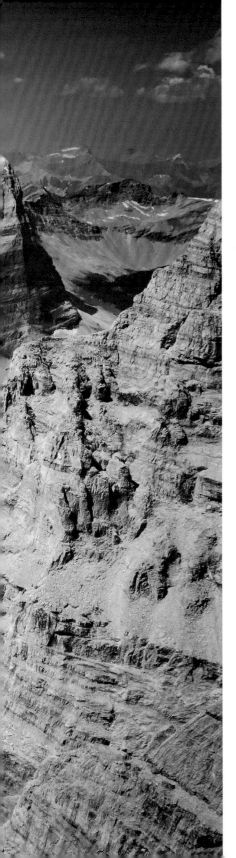

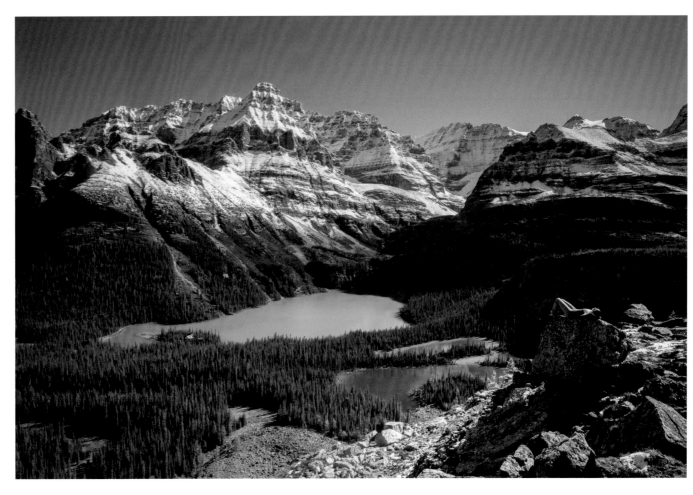

LEFT *Lake Oesa (left) and Lake O'Hara (right) are just two of the spellbinding lakes that make this unique corner of Yoho National Park so famous.*

ABOVE *The day after a summer snowstorm makes for an impressive scene from the Odaray Grandview Trail, with snow-dusted peaks, the turquoise waters of Lake O'Hara and a bluebird sky.*

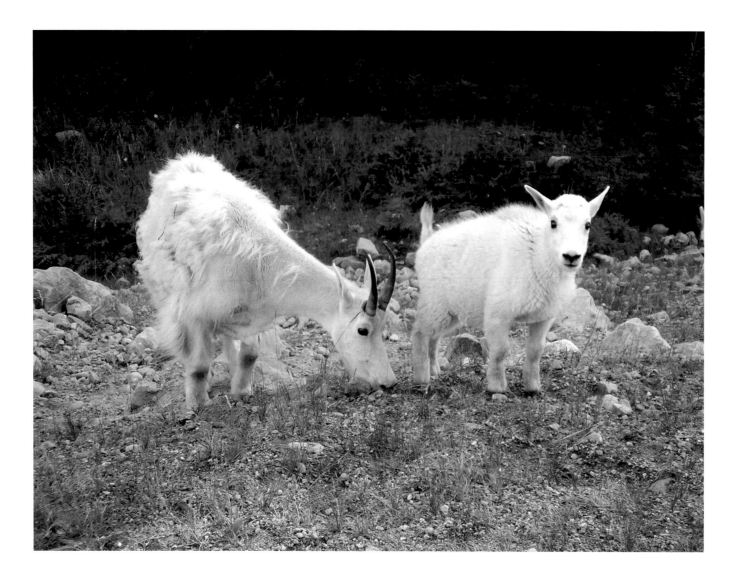

LEFT *Two mountain goats roam the alpine slopes on the Whaleback Trail, Yoho National Park.*

OPPOSITE *Herbert Lake is your first point of interest as you leave Lake Louise and head up to Jasper on the Icefields Parkway.*

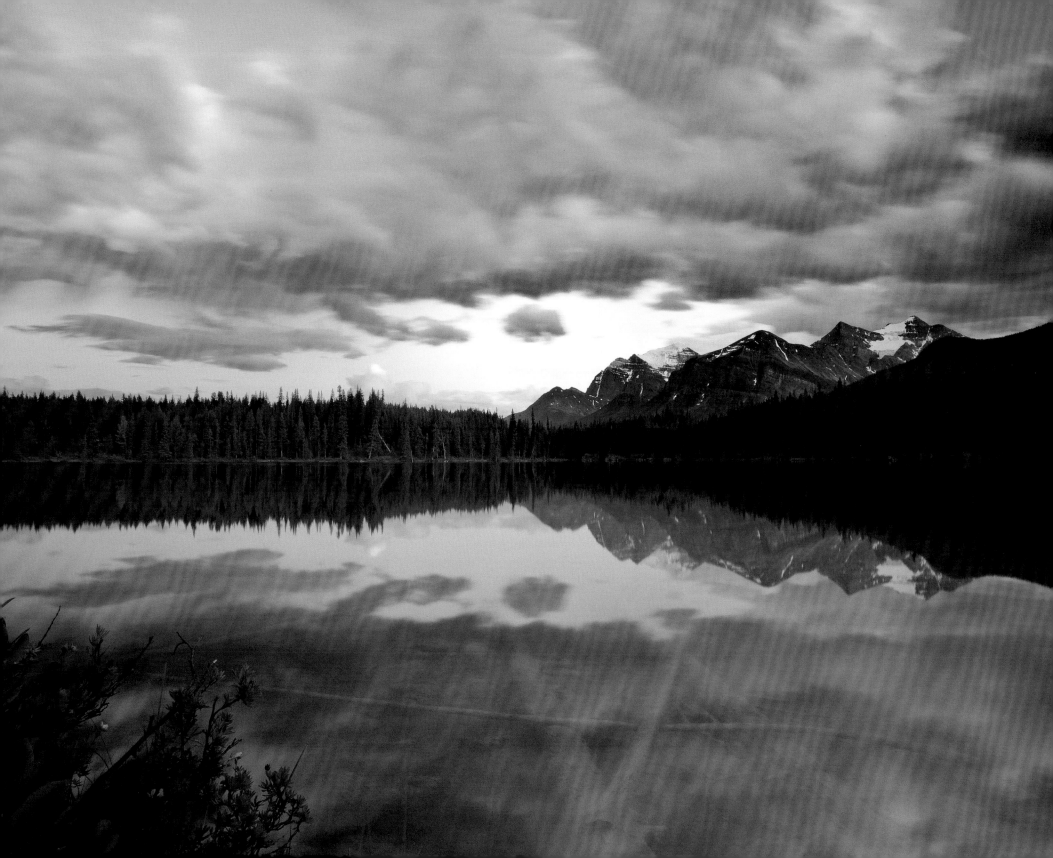

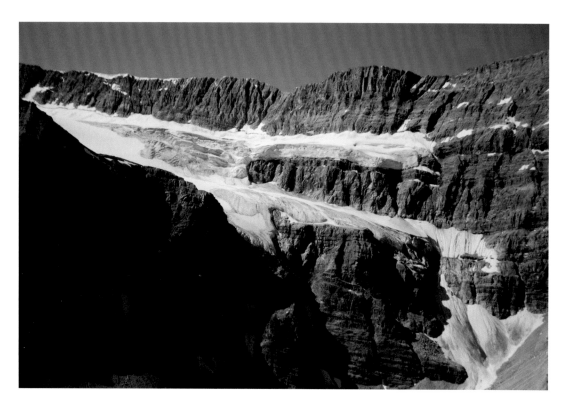

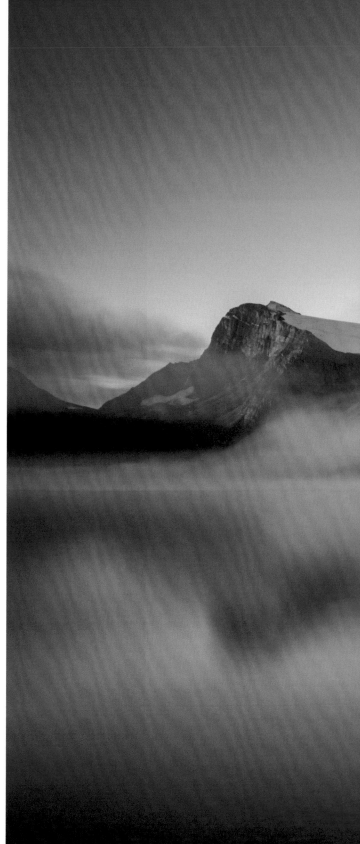

ABOVE *The Crowfoot Glacier clings to the north-eastern flanks of the peak that bears its name. Explorers named the glacier according to its shape, but due to glacial retreat it has lost a "toe" and no longer fully resembles a crow's foot.*

RIGHT *Crowfoot Mountain stands majestically over Bow Lake, the third-largest lake in Banff National Park. It is here that the Bow Glacier melts into Bow Lake – the headwaters of the mighty Bow River, which flows all the way to Calgary and beyond. "Bow" comes from the Peigan name for the river, Makhabn, which refers to the reeds growing along the riverbanks that First Nations used for making bows.*

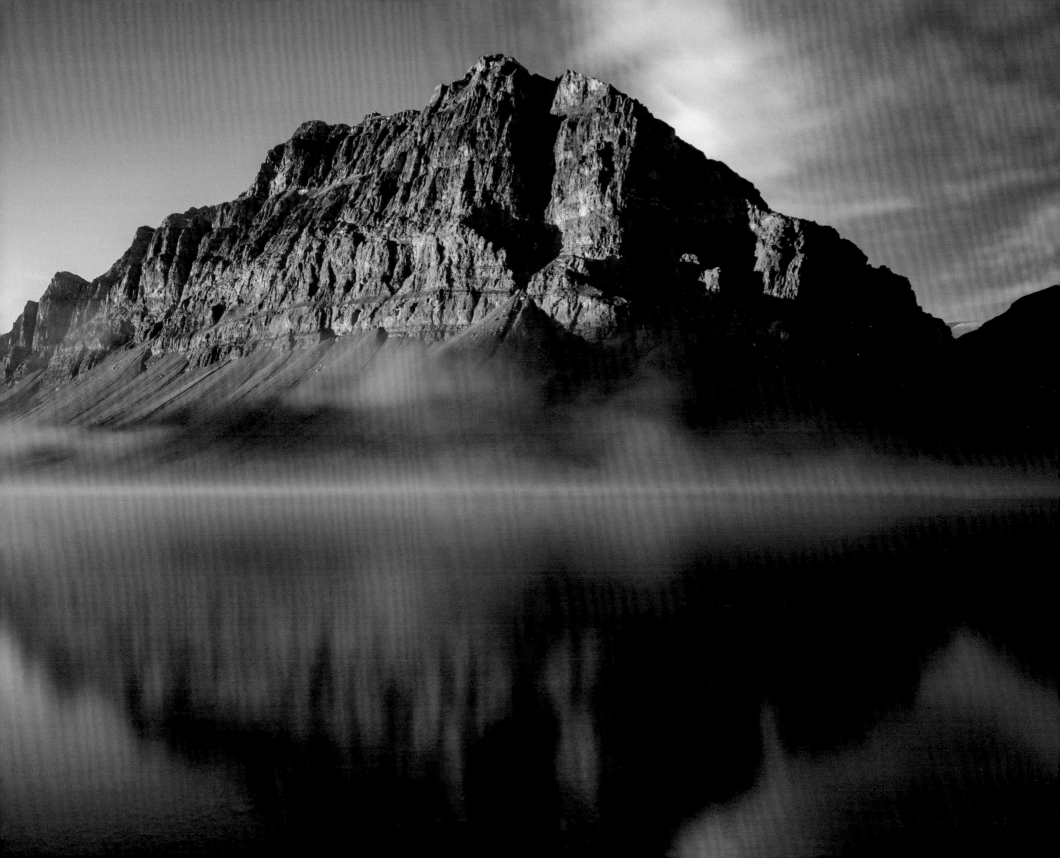

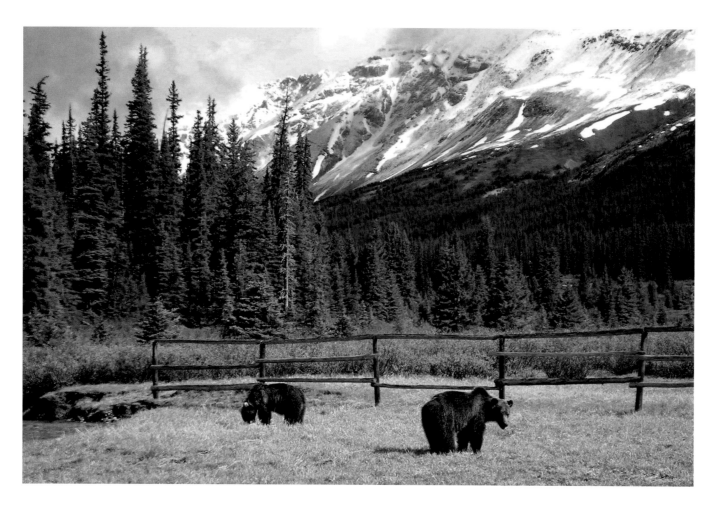

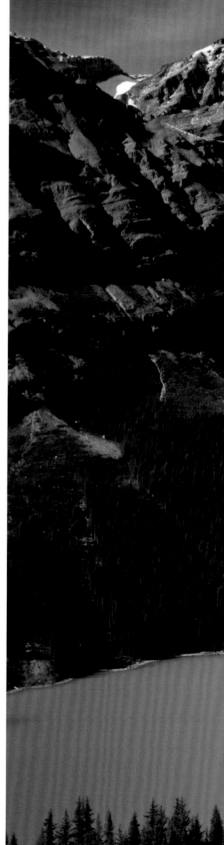

ABOVE *Two grizzly bears forage in an old horse corral close to Bow Lake. Sought after for sightings by locals and visitors alike, approximately 65 of these beautiful wild animals call Banff National Park home.*

RIGHT *Famous for its opaque blue water, Peyto Lake is a popular stop along the Icefields Parkway. It was named after one of Banff's most iconic historical figures, the outfitter, guide and park warden Ebenezer William "Wild Bill" Peyto.*

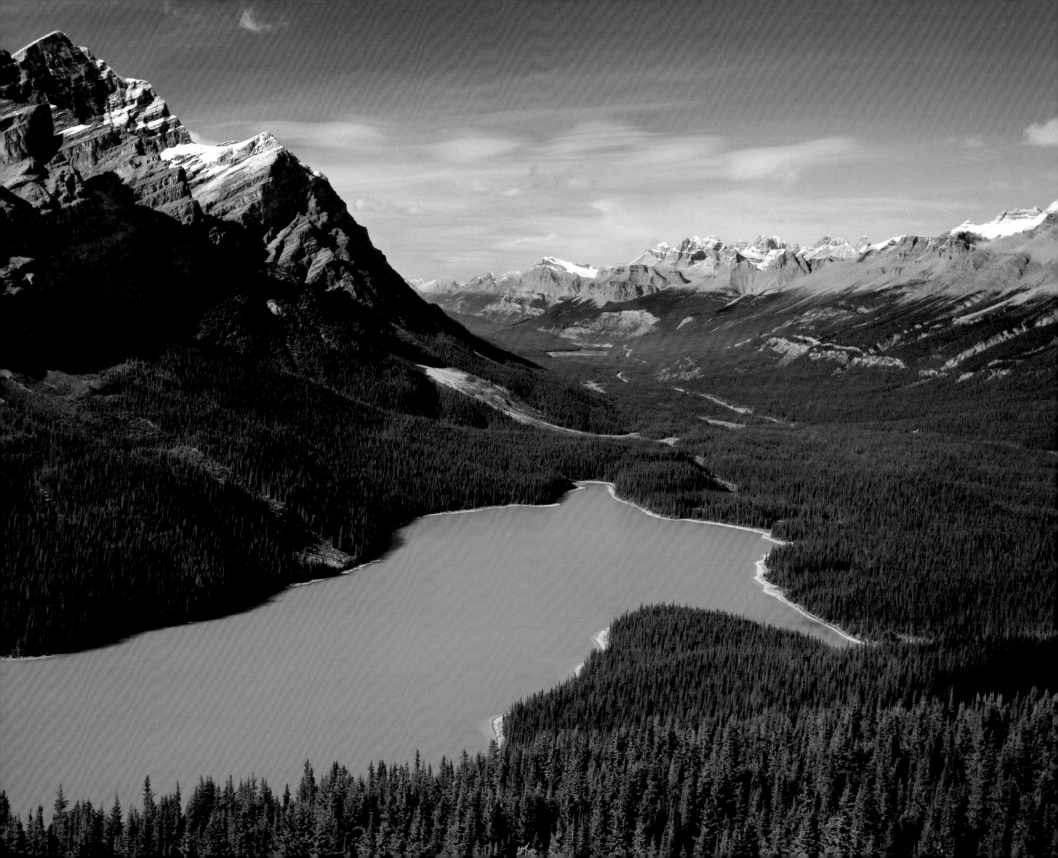

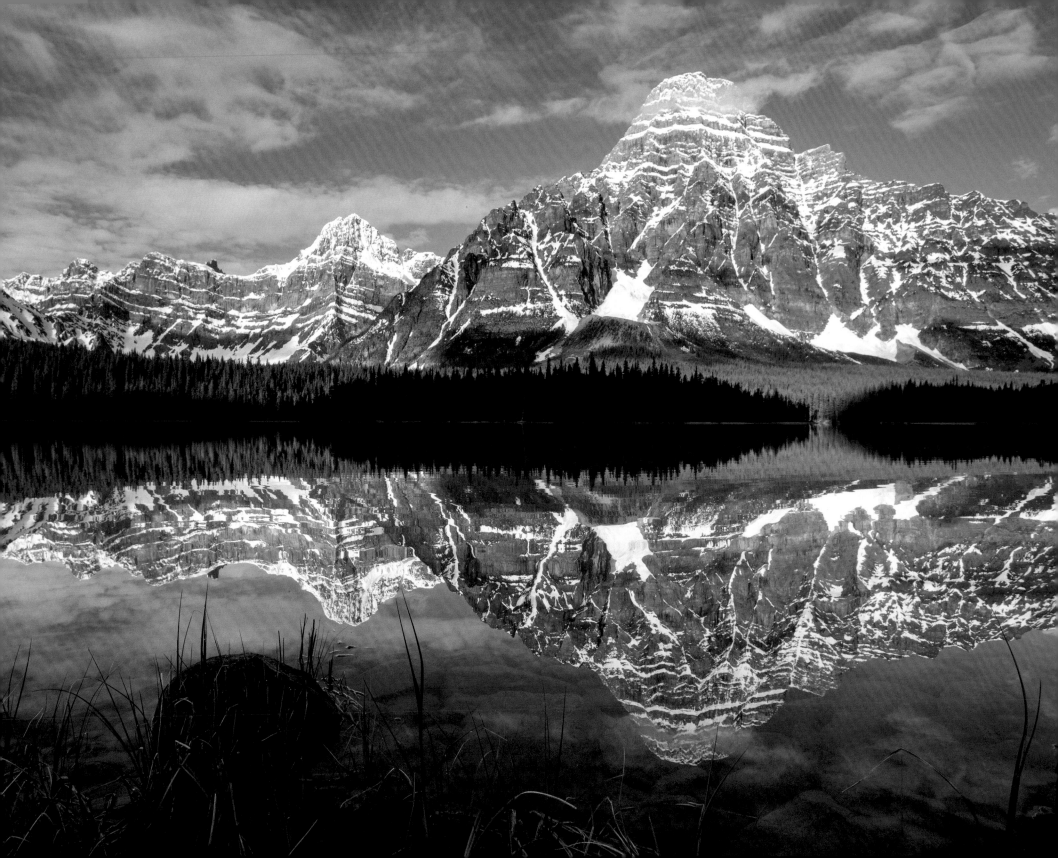

OPPOSITE *Mt. Chephren is reflected in glass-like water at Waterfowl Lake. Under different light, this lake has a bright turquoise colour like the other glacier-fed lakes in the Canadian Rockies. On a single summer's day the colour of the water can change dramatically – a tribute to the dynamic environment of this mountain range.*

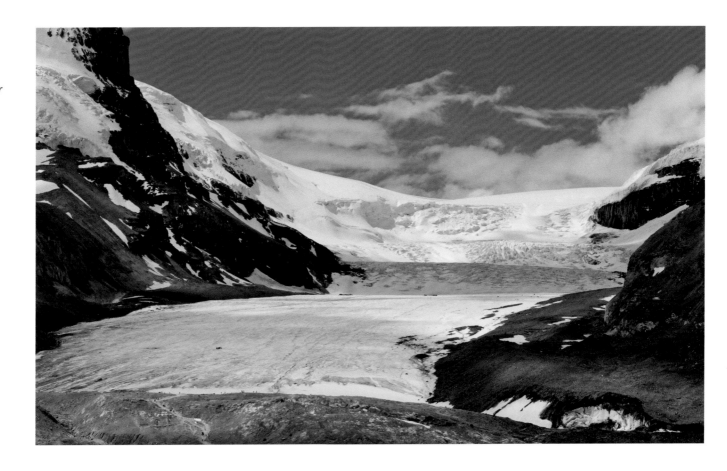

LEFT *One of six "toes" that flow down from the 325-square-kilometre Columbia Icefield, the Athabasca Glacier is an impressive feature on the Icefields Parkway, reaching a depth of about 300 metres at its thickest point. This image shows people close to the toe of the glacier, and the Ice Explorer bus tours about halfway up, demonstrating the scale and magnitude of the ice. Remarkably, due to climate change, scientists estimate it has lost over half its volume in the past 125 years.*

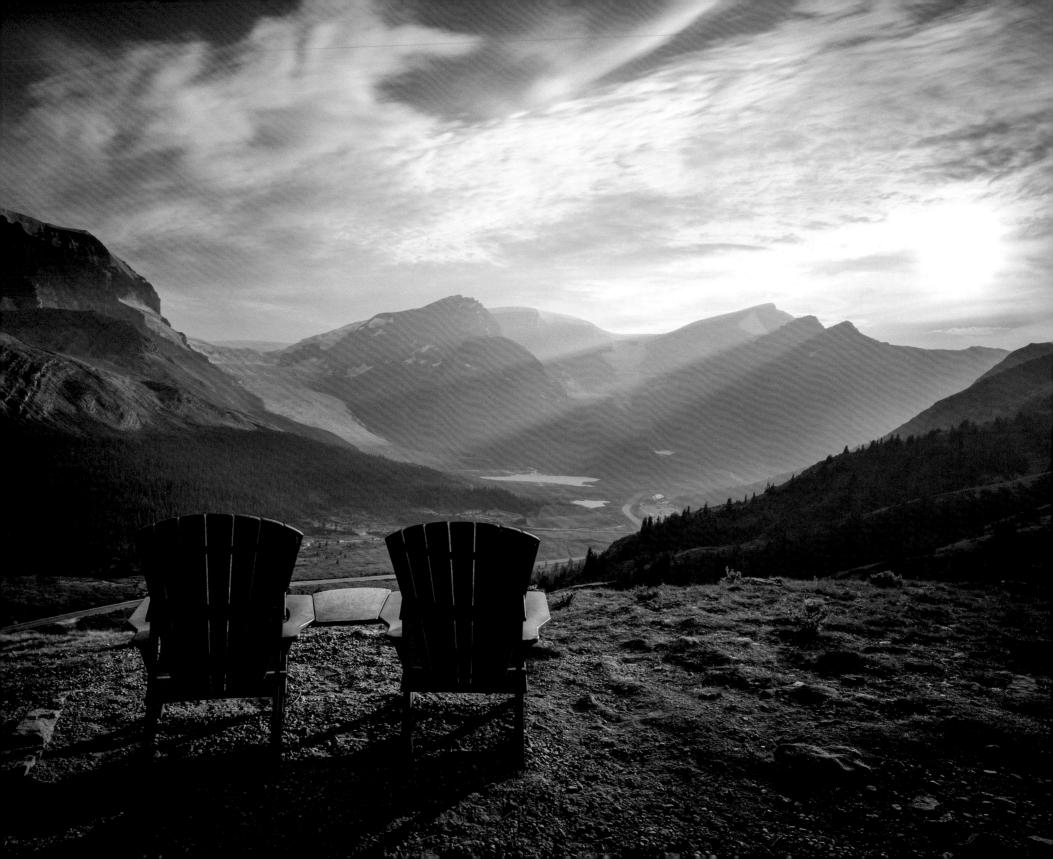

OPPOSITE At Wilcox Pass, Parks Canada's famous red chairs give you a chance to pause and appreciate the glorious view of the Athabasca Glacier, Jasper National Park.

RIGHT One of Jasper National Park's most iconic peaks, the illustrious Mt. Edith Cavell rises to an elevation of 3363 metres. Seen here from Pyramid Lake, the peak was named after an English nurse who helped Allied soldiers escape from German-occupied Belgium during the First World War. For doing so, Edith Cavell was arrested, accused of treason and executed by the Germans in 1915. Memorials bear her name throughout the world, and this striking peak is a fitting tribute to her bravery.

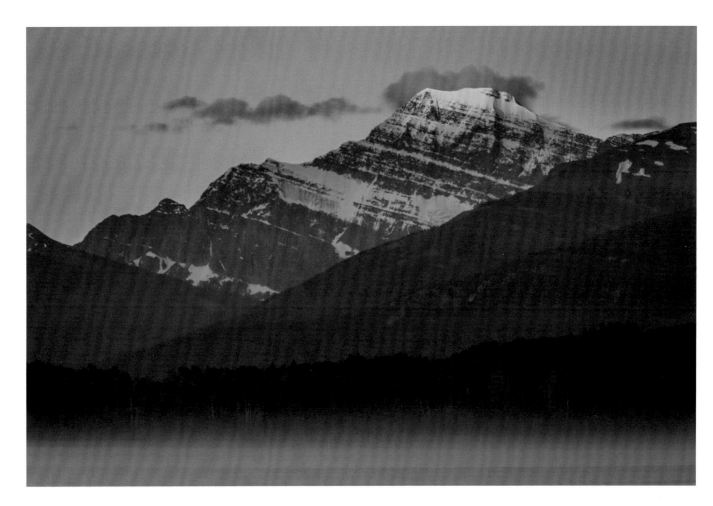

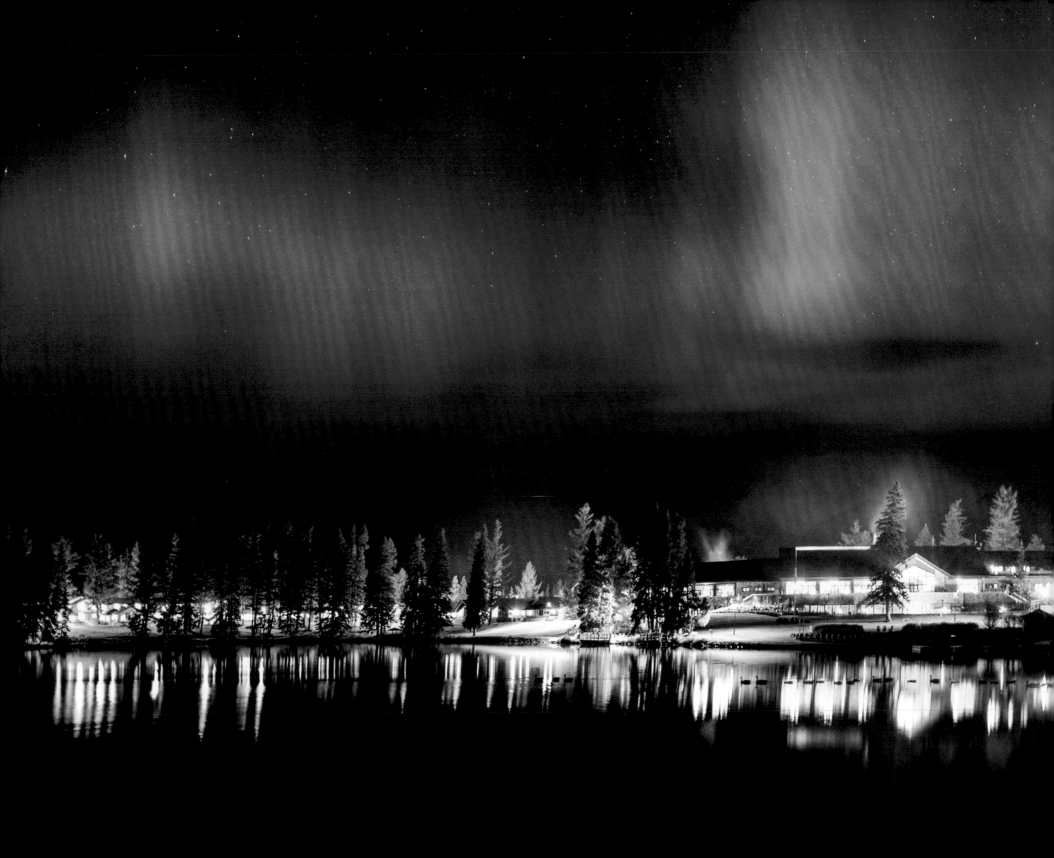

LEFT *The northern lights dance above Jasper Park Lodge, which sits on the shores of Lac Beauvert. First opened in 1922, the hotel has hosted many notable guests, including members of the Royal Family.*

RIGHT *The bright green hues of the aurora borealis light up the shallow water of Medicine Lake, a unique feature on the Jasper landscape. In the summer it fills with glacial water to lake size, and in fall and winter it shrinks to mere pools in a mudflat, connected by a stream (pictured here). Most interesting is the fact that no visible stream empties the lake – it drains out the bottom, through sinkholes.*

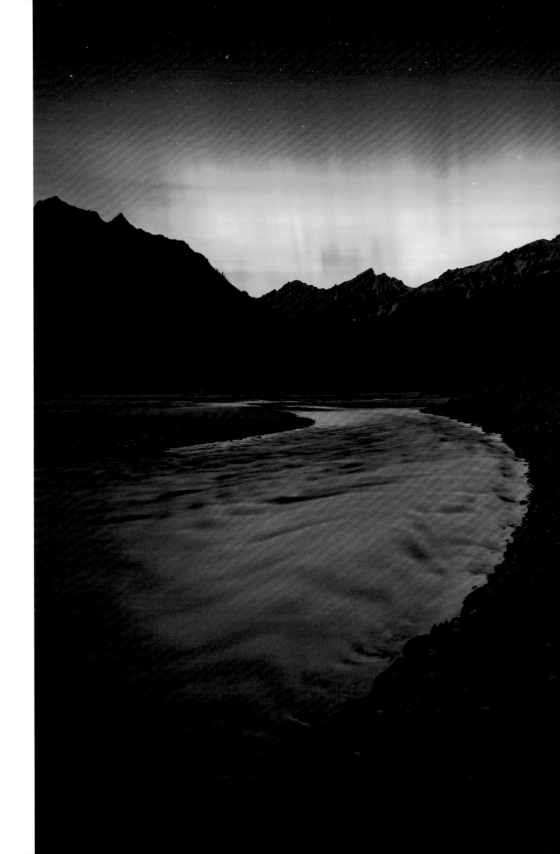

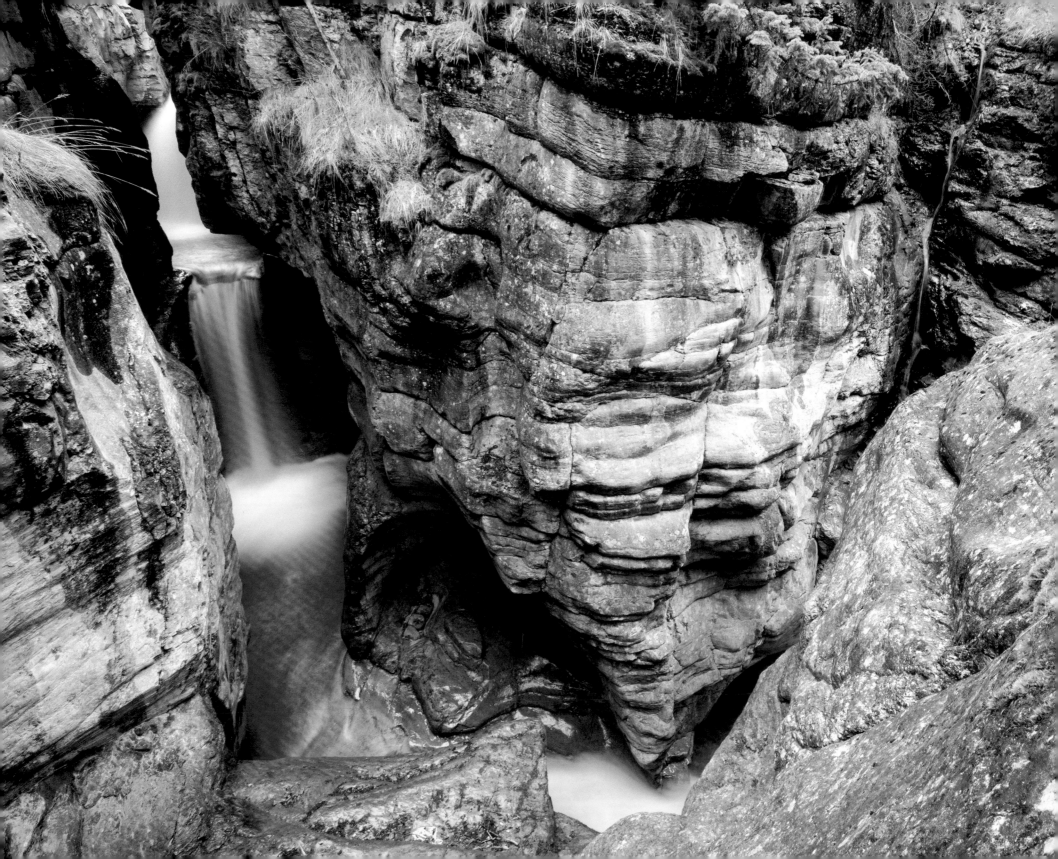

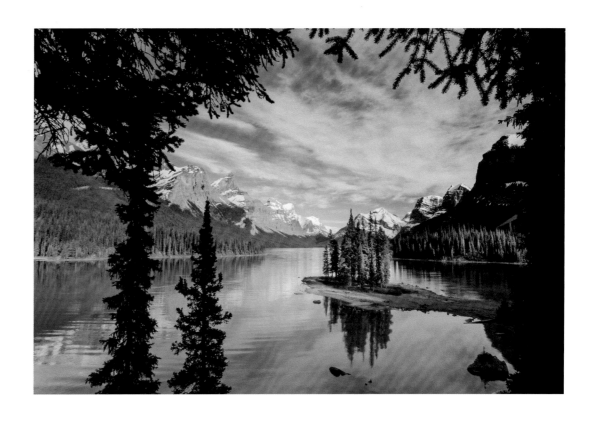

LEFT Measuring over 50 metres in depth, Maligne Canyon features a series of walkways and bridges suspended over the abyss.

ABOVE One of the most famous views in the Canadian Rockies is that of Spirit Island and the dramatic scenery of Maligne Lake, originally called Chaba Imne ("beaver lake") by the Stoney. Mary Schäffer Warren was the first non-Native to reach the lake's shores, in 1908, with the assistance of a map drawn by Samson Beaver. The name comes from the French word for "wicked," which was earlier applied to the fierce currents of the river that flows from the lake.

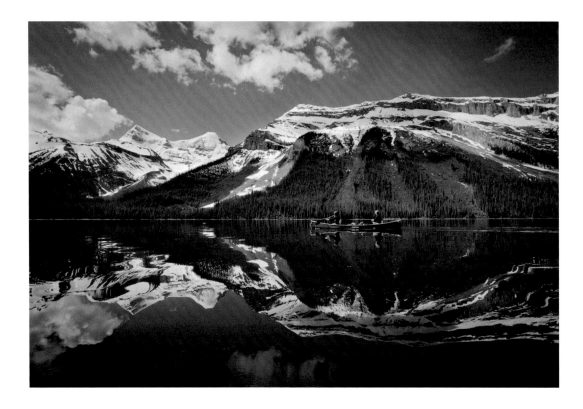

RIGHT *Reaching a lofty height of 3954 metres, Mt. Robson is the highest peak in the Canadian Rockies. Known to First Nations as Yuh-hai-has-kun ("the mountain of the spiral road"), the peak is often shrouded in cloud, earning it the nickname Cloud Cap Mountain.*

ABOVE *The largest lake in Jasper National Park, Maligne Lake is a magnificent location to explore by boat. Visitors are welcome to paddle on their own or hop aboard a Maligne Lake Cruise, which runs throughout the summer season.*

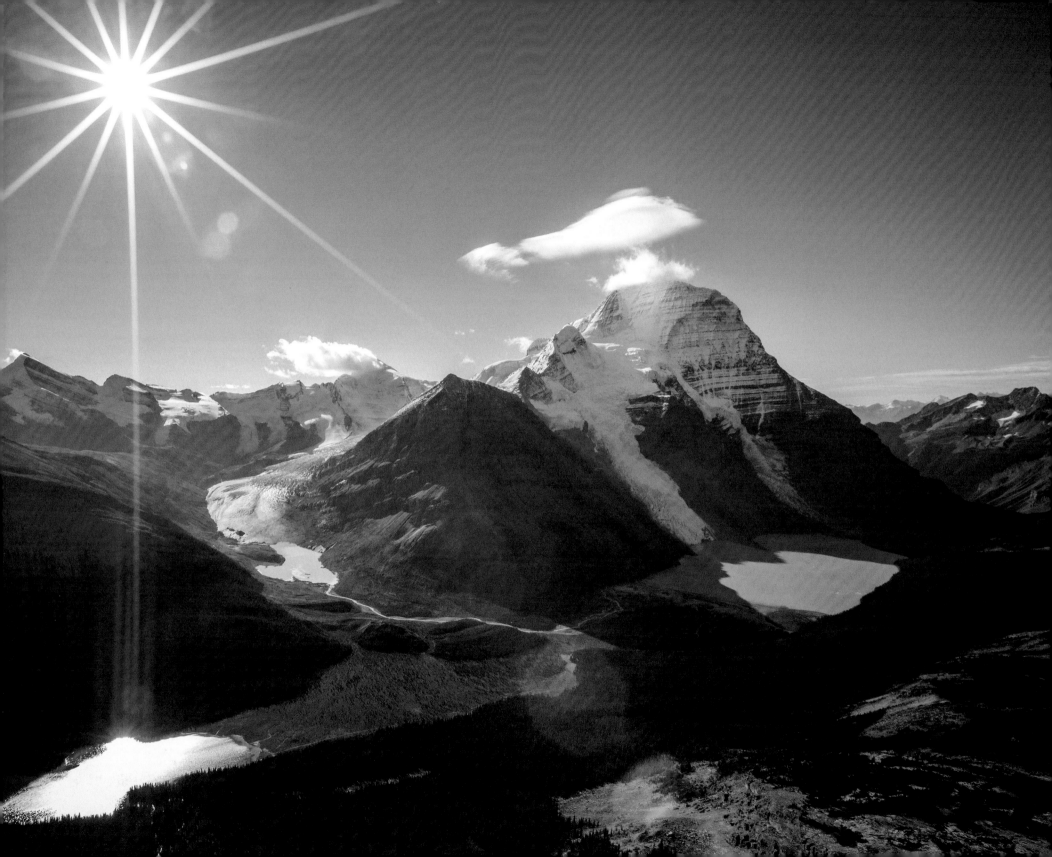

Select Sources

The author wishes to acknowledge the following sources of information for this book:

Peakfinder.com

Wildflowers of the Canadian Rockies, by George W. Scotter and Hälle Flygare

Handbook of the Canadian Rockies, by Ben Gadd

Central Rockies Placenames, by Mike Potter

Banff and Lake Louise History Explorer, by Ernie Lakusta

The Canadian Rockies Trail Guide, by Brian Patton and Bart Robinson

COVER PHOTO *Mt. Rundle and Vermilion Lakes, Banff National Park.*

FRONTISPIECE *One of the most abundant and recognizable wildflowers in the Canadian Rockies, the Indian paintbrush comes in a variety of colours, from blood red to pink or orange and, more rarely, yellow or white.*

Canadä

Canada Council for the Arts Conseil des arts du Canada

BRITISH COLUMBIA

BRITISH COLUMBIA ARTS COUNCIL
An agency of the Province of British Columbia

RMB | Rocky Mountain Books Ltd.

rmbooks.com

@rmbooks

facebook.com/rmbooks

Cataloguing data available from Library and Archives Canada

ISBN 978-1-77160-209-9 (softcover)

Printed and bound in Canada by Friesens

Distributed in Canada by Heritage Group Distribution and in the U.S. by Publishers Group West

For information on purchasing bulk quantities of this book, or to obtain media excerpts or invite the author to speak at an event, please visit rmbooks.com and select the "Contact Us" tab.

RMB | Rocky Mountain Books is dedicated to the environment and committed to reducing the destruction of old-growth forests. Our books are produced with respect for the future and consideration for the past.

We acknowledge the financial support of the Government of Canada through the Canada Book Fund and the Canada Council for the Arts, and of the province of British Columbia through the British Columbia Arts Council and the Book Publishing Tax Credit.